APERTURE

Storyteller

The inherent fascination of the photograph comes from its duality as truthteller and storyteller. Where truthtelling penetrates and describes reality, storytelling fills the timeless need to create fables.

The center of this duality is most apparent in the annals of documentary photography as it evolved in America from the 1930s to the 1980s. By appearing to embody the central artistic and social issues of a time, documentary had as its distinguishing feature an illusion of authenticity.

In 1926, John Grierson first defined documentary as "a selective dramatization of facts in terms of their human consequences," a definition which evolved when photographers of the FSA, under the direction of Roy Stryker, depicted the tragedy of Depression America in human terms. A decade later Stryker organized a drastically different project in the Standard Oil Project's paean to industrial America. The photographs which resulted represented a form of storytelling which ignored the consequences of an unquestioned belief in technology.

A radically different populist and humanist documentary approach emerged in the same decade in the Photo League, an organization that included some of the most significant photographers of the time—Ruth Orkin, Walter Rosenblum, Paul Strand, Sid Grossman, and Dan Weiner, among others. Their potent belief in political change through "the responsibility and duty of recording a true image of the world as it is today" led to some of the finest photographs of the "streets" and the working class ever produced and contributed to their blacklisting during the McCarthy era.

In the 1960s and 1970s, Garry Winogrand's heady, vibrant, chaotic images signaled the uncertainty, edginess, and loss of faith in post-war America and contributed to redefining the terms of documentary in a personal and aesthetic direction. For Winogrand, photography was: "perception (seeing) and description (operating the camera to make a record) of the seeing."

Photographers and artists in the 1980s have adopted the documentary in a call for social change or social scrutiny. Influenced by the work of critics like Roland Barthes and Michel Foucault, the heightened awareness of photography's ambiguity—never neutral, always shaped by context and intention—is explored in the dream-sequences on identity of Vietnamese filmmaker Trinh Minh-ha, the "family stories" of Carrie Mae Weems, the contextual planes of Judith Barry's projections, the seductive word-plays of Lorna Simpson, and the objets-trouvés of Barbara Bloom. These artists are struggling to use the "fact" of the photo image to tell an emblematic and universal tale.

Words regulate time; images determine space, and photographs can create symbols as well as fictions. The photographer as storyteller asks what illusion we choose to affirm.

THE EDITORS

"A Good, Honest Photograph": Steichen, Stryker, and the Standard Oil of New Jersey Project

by Maren Stange

The 1930s changed the face of American documentary photography as government-sponsored projects took the lead in documenting the bitterness and hope of the depression years: the Farm Security Administration, Resettlement Administration, The U.S. Department of Agriculture, the Soil Conservation Service, the Civilian Conservation Corps, the Works Progress Administration, the National Youth Administration. A new era of corporate involvement in the arts was marked by the largest project ever attempted outside of the FSA when Standard Oil of New Jersey employed Roy Stryker, a former director of the FSA project, as part of a massive public-relations effort. Stryker in turn convinced Berenice Abbott, Elliott Erwitt, Lisette Model, John Collier, Gordon Parks, Russell Lee, Charlotte Brooks, Arnold Eagle, Todd Webb, Martha McMillan Roberts, and other significant photographers, some of whose work is included here, to join in compiling an archive of some 67,000 photographs. Their work offers an amazing pictorial record of wartime and post-war America. THE EDITORS

In a famous 1942 memo, Roy Stryker, director of the Historical Section-Photographic of the Farm Security Administration (FSA), called for photographs of "people with a little spirit," particularly "young men and women who work in our factories, [and] the young men who build our bridges, roads, dams and large factories." As his memo suggests, World War II was constraining the photography project to produce abstract, ideological images that could be suitable for propaganda, rather than the more complex representations familiar to us from the depression years. Stryker wanted "pictures of men, women and children who appear as if they really believed in the U.S.," and he urged photographers to concentrate on "shipyards, steel mills, aircraft plants, oil refineries, and always the happy American worker." Their images came to look, according to photographer John Vachon, discouragingly "like those from the Soviet Union."[1] In 1943, the Historical Section-Photographic was transferred from the FSA to the Office of War Information (OWI), and the FSA itself fought to survive in the face of Congressional attacks.

Finding that his position had changed from "editorial director to . . . administrative operator," and that under the OWI the section had become—as he wrote to Dorothea Lange—"a service organization . . . maintaining the files, running the laboratory, and hunting pictures from other Government Agencies," Stryker resigned in 1943, and went to work in corporate public relations for the Standard Oil Company of New Jersey (SONJ).

The new job, Stryker claimed, would help him "find out how the other half of America lives."[2]

Two decades later, in 1962, photography department head Edward Steichen mounted *The Bitter Years, 1935–1941* at the Museum of Modern Art (MOMA). The revival exhibition, dedicated to Roy Stryker, introduced not just the depression itself but also the work of the FSA photographers "into the consciousness of a new generation," Steichen claimed, and it revealed "the endurance and fortitude that made the emergence from the Great Depression one of America's victorious hours."[3] The show featured brief, thematic captions as well as overblown prose. Seven years earlier, in 1955, Steichen had mounted his phenomenally successful *The Family of Man*, which used universalizing, apolitical themes to organize 503 photos from 68 countries, and the choice of images and editorial methods used in *The Bitter Years* drew on the approach made familiar world wide by the earlier show.

The possibility that social documentary photography might continue as a vigorous and variously realized representational form certainly ended in 1943, when the FSA was transferred to the OWI. And, as television usurped photography's pride of place as the most immediate of representational media, the significance of photographic practice as a whole was radically and permanently changed. Nevertheless, a train of events in effect re-made documentary into an institutionalized, "museumified" artifact during and after the war. The story deserves telling not least because of the extent to which exhibitions such as Steichen's have obscured it. It involves key cultural institutions, and it shows how photography was used to forge bonds among government, corporations, and cultural institutions which even today ensure those agencies' cultural hegemony. Not surprisingly, Roy Stryker plays a central role.

The year before he left Washington, Stryker assisted Steichen with MOMA's *Road to Victory* exhibition. A "vivid demonstration of what photography can do to tell a sincere, direct and convincing story," according MOMA board member David McAlpin, *Road* found one-third of its 134 images in the FSA files; the rest came from other government agencies (no doubt via the FSA) or, by solicitation, from industry and individual photographers. As it had done for earlier MOMA war-related shows, the FSA handled the extensive laboratory and darkroom work involved in enlargements and printing of all the government agency photographs.[4]

Developing in the 1940s into a "minor war contractor," as art historian Eva Cockcroft has written, MOMA provided "cultural materials" for the Library of Congress, Office of War Information, and for Nelson Rockefeller's Office of Inter-

EDWIN AND LOUISE ROSSKAM, Oil train crossing the prairie
between Cut Bank and Browning, Montana, August 1944

ARTHUR ROTHSTEIN, Exhibit at Grand Central Station, New York City, 1943

American Affairs. During and after the war, it cooperated closely with government efforts to promote and use American art and photography as propaganda.[5] Steichen, first associated with MOMA's photography department in 1942 and appointed department head in 1947, understood photography's "chief natural functions of documentation and human-interest recording," as a colleague wrote. Indeed, "to prise photographs from their original contexts, to discard or alter their captions, to recrop their borders in the enforcement of a unitary meaning, to reprint them for dramatic impact, to redistribute them in new narrative chains consistent with a predetermined thesis," wrote photographic historian Christopher Phillips in 1982, was standard procedure for the series of thematic exhibitions which Steichen produced for MOMA, beginning with *Road* in 1942 and culminating in 1955 with *The Family of Man*.[6]

Phillips's criticism is directed at the use of such overbearing editorial techniques at a major art museum, which might be expected to privilege "the photographer as autonomous artist [and] the original print as personal expression." In contrast, Steichen's "narrative chains" installed documentary photography yet more firmly in the realm of popular entertainment

and distraction. As Phillips has pointed out, a major reason that MOMA hired Steichen to replace Beaumont Newhall was that Newhall's connoisseur-like curatorial policies distanced the museum from the ever-increasing number of amateur photographers, as well as from other viewers whose esthetics and expectations were formed by what they saw in the popular magazines. Under Newhall's stewardship, the museum was called "snobbish" and "esoteric" in the popular photography journals, and the market for photography remained sluggish despite booms in modern painting and sculpture. Steichen, who later admitted that by the 1940s he didn't "give a hoot in hell about [promoting photography as one of the fine arts]," was hired to correct this situation and was particularly welcomed, not only for his ties to fashion and the media, but also because, as MOMA board president Nelson Rockefeller said, he had "the endorsement and support of the photographic industry."[7]

Road, wrote one celebratory critic in the MOMA *Bulletin*, was "a portrait of a nation, heroic in stature. And as such, needless to say, it is art."[8] The first of Steichen's elaborate installations at MOMA, the exhibition was designed by Herbert Bayer to present images as free-standing or free-hanging murals,

some as large as ten by forty feet, which filled the museum's entire second floor. Through these the viewer walked on a pre-determined route which presented a narrative "photographic procession." Not only did the viewer's progress enhance the metaphor in the exhibition's title, but also the layout persuaded that "Each room is a chapter, each photograph a sentence," as the museum's *Bulletin* proclaimed. With captions and poetic commentary by Carl Sandburg, the exhibition moved "from the landscape of the primeval continent through the folkways of simple Americans, the extraordinary mechanisms of peace and war, to the cavalcade of men flying and sailing and motoring and marching to the defense of that continent," the *Bulletin* explained. Emphasizing the "faces of the men and women who constitute the basic strength of the country," *Road* did not "give us hell," as one critical viewer complained in a letter to the New York *Herald Tribune;* its intention, rather, was to make viewers identify easily with its subjects and feel "part of the power of America."[9]

Though the popular *Family of Man* exhibition was larger and more elaborately installed, *Road* made crucial innovations which were amplified in the later show. At the exhibition's "critical juncture" was an alcove which constituted a specially dramatic point, juxtaposing a typically monumental Dorothea Lange photograph made in 1938 of an American migrant farmer against an equal-sized enlargement of an American destroyer exploding at Pearl Harbor. To this a smaller image of two laughing Japanese men—the Ambassador Nomura and the peace envoy Kurusu, originally photographed for *Life*—had been appended with the caption "Two Faces." "War," read the Lange photo caption, "they asked for it—now, by the living God, they'll get it."[10]

A rationale for such radical manipulation is offered by designer Bayer, who wrote that a modern exhibition, intended to "explain, demonstrate, and even persuade" a viewer to "a planned and direct reaction," should necessarily be designed in way "parallel with the psychology of advertising." Bayer valued narrative for its associations in viewers' minds with other media and their fictive pleasures, key elements of effective persuasion. Not only did the viewers' route proceed narratively through *Road* in a more efficient and "filmic" version of their page-turning progress through the photo-essay, but also the exhibition itself was, from the beginning, "conceived not as a single presentation, but as a set of multiple 'editions' of varying physical dimension intended to circulate—in the manner of motion pictures or magazines—throughout the United States and the world."[11]

Attendance figures show 80,000 visitors to *Road* at MOMA during the summer of 1942, and the exhibition travelled in America to Chicago, St. Louis, Portland, and Rochester. Never intended only for domestic consumption, it was shipped in smaller versions to Latin America, Britain, and the Pacific. Not only the large attendance and the extensive tours, but also the very terms of critical praise underscore the dimensions of MOMA's bid to establish photography once for all as an art

that was simultaneously a form of popular culture. Choosing among reviews apparently unanimously positive, the MOMA *Bulletin* reprinted comments that stressed the exhibition's appeal to "everyone with two eyes and a heart," as *PM* magazine put it, an appeal that would "keep the Museum of Modern Art packed for months to come." *Road* did not identify and implicate the viewer so thoroughly as would *Family of Man*, which was set up in such a way that the viewer at one point faced a mirror strategically placed in the midst of nine identically-sized portrait photographs. Nevertheless, *Road* enacted Bayer's injunction not to "retain its distance from the spectator." Like the movies, it was meant to be viewed in a crowd. And, like advertising, it not only commodified and quantified the esthetic experience it offered, but it also flattered its viewers' specular passivity: its ceaseless self-congratulation proposed that mass participation in appreciation was actually, like artistic creativity, an activity which confirmed and strengthened individual identity.[12]

Rockefeller's Office of Inter-American Affairs, which circulated *Road* in Latin America, also toured nineteen exhibits of contemporary American painting during the war as part of MOMA's international programs. And like Rockefeller himself, who was president of MOMA from 1939 to 1940, and again in 1946, staff members from Inter-American Affairs moved into international leadership positions at the museum during and after the war. In the same way, a personal connection linked the museum in the 1950s with the Central Intelligence Agency (CIA). Thomas W. Braden left a position as executive secretary of MOMA in 1950 to join the agency as supervisor of cultural activities.[13]

The reasons for the museum's key participation in quasi-official international cultural exchanges have been made abundantly clear in recent scholarship. "Handcuffed," as Cockcroft has written, "by the noisy and virulent speeches of right-wing congressmen like Representative George A. Dondero (Michigan) who from the House floor regularly denounced abstract art and 'brainwashed artists in the uniform of the Red art brigade,'" official government agencies could not openly sponsor the avant-garde art that was to establish the United States internationally as a genuine contender in the "cultural war" with the Soviet Union. Supported by the Rockefeller family, the museum "in effect carried out government functions" in the cultural arena. The museum's explicitly political purpose, according to its historian Russell Lynes, was "to let it be known especially in Europe that America was not the cultural backwater that the Russians . . . were trying to demonstrate that it was."[14]

In addition to their geopolitical imperative to use art internationally to demonstrate that "cultural advancement and political freedom were interdependent," as the CIA's Braden put it, the government and private capital had other reasons to promote artistic activity on the domestic front.[15] Artists sustained by New Deal projects in the 1930s needed new buyers and patrons in the 1940s. During the war years that had ended unemployment but provided few consumer goods, Americans had

SOL LIBSOHN, Iron workers atop a guy derrick
adjust one of the lines, Bayway Refinery,
Linden, New Jersey, 1948

SOL LIBSOHN, Trucker driving at night,
U.S. 22, Pennsylvania, May 1945

amassed huge savings they were now ready to spend. The post-war purpose of museums, dealers, and artists themselves was to reorganize and open up the American art market to include American artists, traditional and avant-garde alike.

Beginning with "Buy American Art" weeks held in 1940 and 1941, and attaining a "picture boom" in 1944, the art world and the media found new ways to publicize, advertise and sell American art to record numbers of buyers. Although, as art historian Serge Guilbaut contends, "art became a commodity," and the "gallery a supermarket" for the masses rushing to consume, an art purchase "still made it possible for the harried buyer to gain in status by being seen as a "cultivated man." Jackson Pollock, his "exuberance, independence, and native sensibility" domesticated, despite his aspirations, into a "perfect commodity," became, of course, "the perfect symbol of the modern painter" in this newly arranged and more populous art world.[16]

Although Roy Stryker's new position in private enterprise with SONJ can be regarded as the confirmation of long-established interests, he seems to have made the actual move with more than one kind of ambivalence. The curiously backward look implicit in his invocation of the phrase Jacob Riis made famous—"how the other half lives"—to describe his job suggests, at the least, unreadiness to face the implications of a new moment in the cultural history of the arts which he himself had done much to bring about. Conceived in wartime, SONJ's program was intended to repair damage done to the company's public image by the revelation that a 1929 cartel agreement it had made with Germany's I.G. Farben-industrie had delayed American development of synthetic rubber and had thus, however inadvertently, actually "enhance[d] Nazi military strength while penalizing American [war efforts]."[17] When an Elmer Roper poll showed that a majority of Americans had feelings that were "not so friendly toward Standard Oil Company of

ESTHER BUBLEY, Mixed quartet singing during evening prayer service in the Baptist Church, Tomball, Texas, May 1945

CHARLES ROTKIN, Rock Island railroad roundhouse,
El Reno, Oklahoma, November 1948

New Jersey," the company established its first public relations department in early 1943 with the consultation of Earl Newsom and Company public relations agency. Edward Stanley, a Newsom executive who had come to know and admire FSA work as Executive Photography Editor for the Associated Press during the late 1930s, and who had worked in 1943 with Roy Stryker in the Domestic Services Branch of the OWI, borrowed unabashedly both scope and operating procedures from various New Deal agencies. Choosing for his staff a number of photographers who had been with him at the FSA and the OWI, Stryker planned for a file of at least 25,000 photographs documenting every conceivable aspect of the production and consumption of oil. In 1949, when the project began to be phased out in favor of other types of publicity, its archives included some 68,000 photographs, including 1,000 color transparencies and 15,000 images documenting SONJ operations abroad.[18]

"Well-to-do, happy, free whores" at SONJ, as photographers Edwin and Louise Rosskam described themselves to an interviewer in the 1970s, they had "very little respect for the project [because] the underlying thing in it . . . was so corrupt." Though it offered more freedom to Stryker and to photographers than was possible under the prescriptive subject-matter requirements of the OWI, the project did not avow the principles of democratized art and communication that had been fundamental to the New Deal projects. Rather, in accord with public relations theory and current views of art, it developed a kind of cultural propaganda—like that which would later be sponsored or funded by the CIA and USIA—which was intended to be effective for a specific audience. The project meant to influence important but problematic "thought leaders"—educated and sophisticated individuals "more conscious of art than the public as a whole," who were also found to be the most critical of Standard Oil Company. Estimated at about 20,000, these sophisticates were considered by the public relations department to be "the ones you really want to get to."[19]

Part of a larger program to use art to influence public opinion, the photography project was ultimately unsuccessful on its own terms. Nevertheless, it represented a considerable step forward in the exploitation of the visual arts as a corporate-funded "servicing agency for mass culture."[20] Conserving what was useful from New Deal precedent, SONJ developed new ways to offer the prestige of art and cultivated entertainment in exchange for positive public opinion. The company's use of art meant to distinguish itself by an emphasis on creating a documentary record, as Steven Plattner has pointed out, and its graphics and visuals were intended to evoke "a certain quality of boldness, . . . integrity or honesty," as Edward Stanley has described them. However, the consolidation of these purposes into documentary photography and film was not automatic. In 1944, SONJ commissioned a number of painters to record the oil industry's role in wartime, a project which Stanley saw as one component of a sophisticated "artistic orientation," ben-

eficial at a moment when even abstract art was featured in popular magazines as well as New York journals. Evidently, the company soon perceived painting as too great a risk: "Take the communist crap away from here and bring me a good, honest photograph," one member of the board of directors is reported to have said when he realized that some of the paintings were abstract rather than strictly representational. For the rest of the decade, the company confined itself to documentary photography and to the well-known documentary film, *Louisiana Story,* by Robert Flaherty, commissioned in 1944, and released in 1949.[21]

Indeed, as a sympathetic *Fortune* writer said in 1948, "Jersey officials hope that the visual record of the industry's operations will help create a more favorable impression, here and abroad, of free enterprise, the capitalist system, and democracy." Pointing out that "the majority of the pictures are quite directly related to oil," the writer went on to note as "significant" the fact that "*any* industrial enterprise provides the opportunity of recording as much of the American scene as these photographs have done." Unduly modest perhaps, the observation is nevertheless perspicacious, for it points out the particular success of the SONJ project: its photographs represented, with the force of documentary authority, what was in fact the crucial significance and real subject of the project itself—that is, the corporate penetration of virtually all areas of American life. The photographs—in their diversity "far more representative of technological and consumer-oriented America . . . than their [FSA] predecessors," as Edwin Rosskam wrote—and also the structure of their sponsorship bear this out.[22]

However, to "tell the story of oil from the jog on a seismographer's chart to the car, home, or business of the user," as Stryker wrote, and to show from a pro-corporate point of view that "people and not the machines they work with are what is important in our industrial civilization," required deployment of all the graphic appeal and sentimental "progressive humanism" (in Roland Barthes' phrase) which documentarians had developed throughout the 1930s.[23] Yet, the project's history suggests that its artfully "revelatory" presentation of its message came actually to constitute a kind of self-defeat. Despite exhortations to photographers to think "in terms of stories," and despite efforts to "get more and more of the pictures into *Life* magazine and the other big magazines," Stryker found himself unable to compete with the work of independent professional photojournalists. The SONJ photographs found many outside uses and appeared in *Fortune, Time, Life, Vogue,* and the *Saturday Evening Post.* However, finding that their credibility rested upon the maintenance of an apparently balanced, "objective," or pluralist, point of view, mass circulation magazines usually preferred to assign or to buy work directly from photographers, or to print SONJ photographs without credit lines. In 1948, when SONJ found that its public image had improved only slightly since 1942, and that it had no way to measure the

public-relations impact of the photography project, the company began gradually to eliminate it. In 1950, Stryker left to become director of the Pittsburgh Photographic Library.[24]

The somewhat different tack the company took in its sponsorship of Flaherty's film, apparently with Stryker's encouragement, was more successful. Though the film publicized the often fruitless work involved in the early stages of oil exploration, and thus presented oil companies as willing risk-takers on the public's behalf, it carried no on-screen acknowledgment of SONJ sponsorship. Rather, the company's free-handed commission of a great filmmaker, who happened to be "the symbol of the creative American, untouched by commercialism or big business" in the eyes of post-war Europeans, was relied upon to generate word-of-mouth goodwill. The heavily symbolic art— or artiness—of the film's narrative "reconciliation of industrial progress with the natural order" enhanced positive associations. Sidestepping problems of distribution and of credit assignation that plagued the photography project, SONJ found in documentary film a medium which could purvey art to a large, yet self-selected, audience, similar to the viewers that television would gather in the 1950s. Indeed, as the international success of *Louisiana Story* had helped the company to realize by 1950, television was a better way to reach the "thought leaders" on whom good public relations depended.[25]

The photography project's failure as a mass-culture vehicle for corporate public-relations may have resulted, ironically, from the same stylistic features that forestalled its success as art. Stryker had perceived the necessity for perceptible, even individual, style in mass culture imagery. In Willard Morgan's *Encyclopedia*, he emphasized documentary photographers' "love for life" and "combination of the emotional and the sensory."[26] However, he seems not to have realized the currency of a stylistically signified "objectivity" as an important criterion for visual expression in the increasingly image-saturated, postwar culture. Objectivity had become an ideal, sociologist Michael Schudson has noted, "precisely when the impossibility of overcoming subjectivity in presenting the news was widely accepted and . . . precisely *because* subjectivity had come to be regarded as inevitable." Although the term "objectivity" was "common parlance," Schudson writes, it was not much-vaunted objectivity, but in fact "the social heritage, the 'professional reflexes,' the individual temperament and the economic status of reporters" that had assumed "fundamental significance" as early as the 1930s.[27]

In other words, even for photojournalistic professionals, success was associated less and less with the content or substance of their work; rather, success came to measure above all the ability to generate and control esthetic response, a stylistic accomplishment which signified, in journalism, versatility, flexibility and professional detachment from subject or content. In such an atmosphere, it was not difficult for critics in the realm of art and culture to suggest that personal or political commitment, and realism itself, were somehow impediments to first-rate accomplishment. Even MOMA's Alfred Barr, in an article for the *New York Times* in 1952, equated non-abstract art with the "reactionary dogma" of both right and left "totalitarianism."[28] The very ease with which Stryker suited his work to corporate sponsorship may have disguised for him its role in sustaining a "free world" imperialism intimately linked to the repressive aspects of Cold War politics that, it can be said, he himself ultimately suffered from. Efforts such as Barr's to associate any and all art forms with specific political views and values were widespread, a kind of ideological terrorism. A direct casualty of cold war repression was the leftist Photo League, placed on the Attorney General's list of subversive organizations in 1947 and forced to disband in 1951. Even though, as Serge Guilbaut has argued, it was their rebellion against Cold War "political exploitation" that led a "progressively disillusioned" Abstract Expressionist movement to "suppress . . . emotional content, social commentary, [and a once-intended] discourse" in their work, the artists' social disengagement and apoliticism were cautionary and compelling examples to wide audiences. Not only in journalism but in high art as well, Eva Cockcroft has pointed out, "objectivity" was specifically valued as a "free world" attribute.[29]

In 1955, the year that Steichen mounted *The Family of Man*, Robert Frank began the travel "on the road around practically forty-eight states in an old used car (on Guggenheim Fellowship)" that would result in the publication of the *The Americans* in 1959.[30] Frank's solitary tour marked a departure in his own career (Steichen used several Frank photographs in *The Family of Man*), and it also addressed, in specifically photographic terms, the manifestations of an image and information order rapidly reorganizing in response to the domination of television. Exploiting neither the privileged "class tourism" of documentary nor the comforting "proximity" to viewers and their social world recommended by Bayer, Frank used banal subjects and a grainy, high-contrast style to emphasize both social and technological mediations. Though the photographs offer a subversive alternative to the emptiness of mediated, consumer culture, they do not hesitate to place their own medium under indictment, proposing that photographic realism, no different from other mediations, can proliferate distortion and falsification as readily as transparency and verisimilitude. Spurning so openly any engagement with photography's long-cherished aspirations to immediacy and transparency, Frank's iconoclasm was not welcomed in all quarters: reviewer Bruce Downes called him "a liar, perversely basking in the kind of world and the kind of misery he is perpetually seeking and persistently creating." But even to sketch out the distinguishing features of Frank's photography is to point to the beginning of a new chapter in photographic expression with its own logic and direction. This chronicle deserves, and is receiving, its own, discrete history.[31]

From *Symbols of Ideal Life: Social Documentary Photography in America, 1890–1950,* to be published in November, 1988, by Cambridge University Press.

JOHN VACHON, Beehive coke ovens along U.S. 60
near Boomer, West Virginia, October 1947

Cezanne's Apples and the Photo League

A Memoir by Louis Stettner

The Photo League, a volunteer organization of amateur and professional photographers located in New York City from 1936 to 1951, numbered among its members, guest speakers, and teachers the most illustrious photographers in America in the 1930s and 1940s. Born from a belief in social change and the ability of the image to affect it, the League eventually fell victim to the histrionic political climate of the 1950s and was forced to disband. Its members left behind a legacy of documentary photography that remains one of the most impressive in this country. In this memoir, Stettner, a long-time member of the League, shares his sense of the history of that time.

THE EDITORS

TO THE ESTHETES

*Dust from your eyes
makes barren the landscapes on your walls
all done by famous hands
and bought at a notorious cost
for your private desecration.
Never, you shall never
be as common with creation
as the present you shudder from.
Cezanne in him
found fellow feeling;
not in you.*
ISIDOR SCHNEIDER
Mainstream, Spring, 1947

One cannot help but be intrigued, even fascinated, by the contradictory fate history has meted out to the Photo League. Perhaps no other artists' organization in America has been so condemned by government officials, and yet so enthusiastically explored by those with a passion for photography as fine art. Hardly a year goes by without the photographers of the Photo League made the subject of an essay, an article, a learned thesis, or an exhibition. While some new facts are unearthed, and some valuable insights recorded, the main essence of the Photo League seems to have been blurred or distorted. History has been rewritten into something the Photo League simply never was.

Born out of the rich and varied political ferment of the twenties and early thirties, the League was, above all, the first pro-gressive, left-wing photography organization in the United States. Its origins go back even earlier, to the Pen and Hammer Club, organized around socialist concepts predicating a unity between artist-intellectuals (mostly writers) and working people. John Reed, its most illustrious member, was a committed journalist, who joined Pancho Villa in the Mexican Revolution before going to Russia in 1917 to write the monumental *Ten Days that Shook the World*. In 1928, motion-picture and still photographers formed the Film and Photo League, which, after the departure of the motion picture members in 1936, became the Photo League. The Photo League was organized and run by the photographers themselves. Dues were relatively small, and if one could not afford to pay, one could earn membership by sitting at the desk during exhibitions or by helping in the darkroom. It was not a catch-all organization that stayed clear of troublesome policies and goals in order to have as large a membership as possible. Those who joined knew they were sharing a common orientation and direction in their art, a documentary approach that was progressively left and people-oriented. As an organization, it had two important goals: first, through activities, exhibitions, school lectures and publication of *Photo Notes*, the development and encouragement of photography as a fine art; second, the use of photography as a tool to help working people in their struggles, and to document and interpret their daily lives.

For radical political ideas to have an important influence on artists and movements is not new in art history: Pablo Picasso was deeply moved by the anarchist and socialist movements that flourished in Barcelona at the turn of the century, and during the Spanish Civil War harbored Republican refugees in his studio. His famous *Guernica*, produced for the Spanish Pavilion at the New York World's Fair in 1930, testifies to that belief. Robert Henri, an ardent socialist and an influential art teacher, first in Philadelphia and later at the Art Students League in New York, became the mentor of John Sloan, Edward Hopper, and the so-called "Ash Can" group of painters. Instead of depicting prosperous merchants posing in front of sentimental, carmelized sunsets, they took as their subject matter the working people of New York: bathers at Coney Island, office secretaries partying under the Third Avenue El, children playing in back alleys. The Ash Can artists were appreciated by several important photographers experimenting with hand-held cameras: Alfred Stieglitz and members of his group, as well as Paul Strand

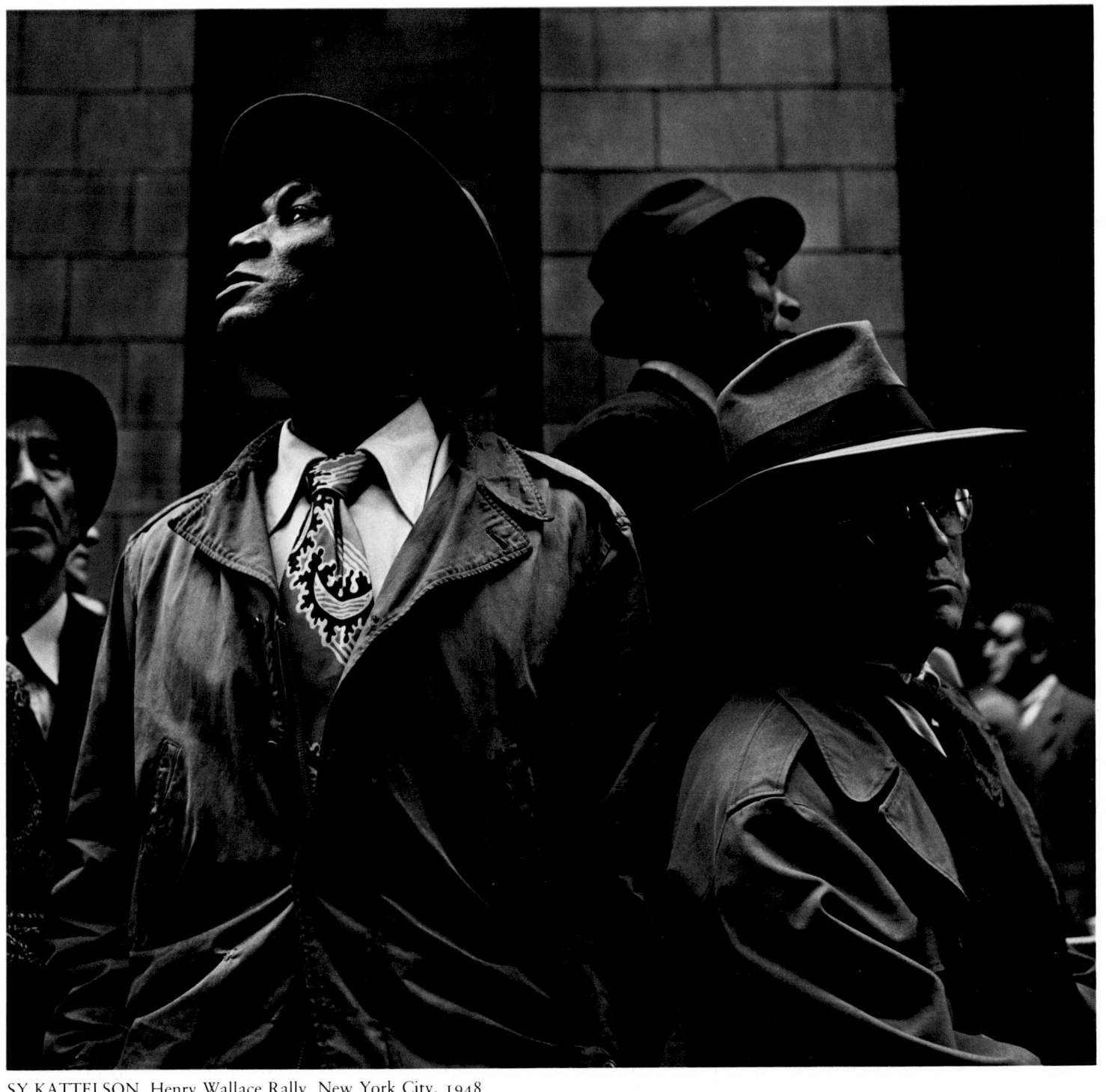

SY KATTELSON, Henry Wallace Rally, New York City, 1948

HAROLD ROTH, Bowery at Houston, New York City, 1946

doing his first candid camera series in New York streets. Later, the Ash Can school served as valuable forerunners for the Photo League photographers working on their numerous street projects. It may come as a surprise to some to learn that the street photography, so commonplace today, was born of a political concept.

Aside from its political antecedents in art, myriad factors went into the formation and growth of the Photo League. During most of its formative years, America was reeling from the devastation of the Great Depression: hunger, bread lines, evictions, and the selling of apples and valuables on the streets were in evidence everywhere. During the depression, artists joined the people struggling on many different fronts. The Works Progress Administration nurtured the photographers Dorothea Lange, Minor White, and others, and such painters as Ben Shahn, Thomas Hart Benton and Jackson Pollock (who, they say, was inspired by paint drippings on the floor while making signs for demonstrations). But this work for artists was not offered to them on a platter: weekly wages for artists were won after picketing and protest parades of as many as 5,000 painters, lasting weeks, won sympathy for their cause. Other battles for unemployment insurance, unionization, and minimum wages improved working conditions nationwide. Later, when the American people mobilized the necessary strength and heroism to help destroy Fascism, the progressive left played an important role by helping them organize.

The Photo League was not just a reaction to the Great Depression; it also grew out of a tradition in American photography represented by Stieglitz, Hine, and Strand. Lewis Hine and Paul Strand were frequent visitors to the League (I remember helping to make prints from a Hine negative for a fundraising event). Since quality printmaking was emphasized, there were serious debates concerning the merits of gold-toning, ferrocyanide, and other materials. An exhibit of Strand's Mexico portfolio, superbly printed in heliogravure, and varnished to give luminosity to the shadows, encouraged League members to try and get emotional values in their prints by means of tonalities, texture, and great detail. It was Strand's contention, which he very clearly articulated, that all visual media obey the same esthetic laws, so that one could compare the qualities of blacks in an etching with those of a silver print. The first New York exhibition of Edward Weston's 4 x 5 California portraits also encouraged fine printmaking among the Photo League photographers.

The League had an international outlook, exhibiting photographers from all over the world. Manuel Alvarez Bravo from Mexico and others had their first New York shows at the Photo League. After the war, I went to France and sent back the first collection of contemporary French photographers to be exhibited in the States: Brassaï, Doisneau, Izis, Boubat, and others. Brassaï once told me that it was the success of this show and its publication in the international *U.S. Camera* that led to the

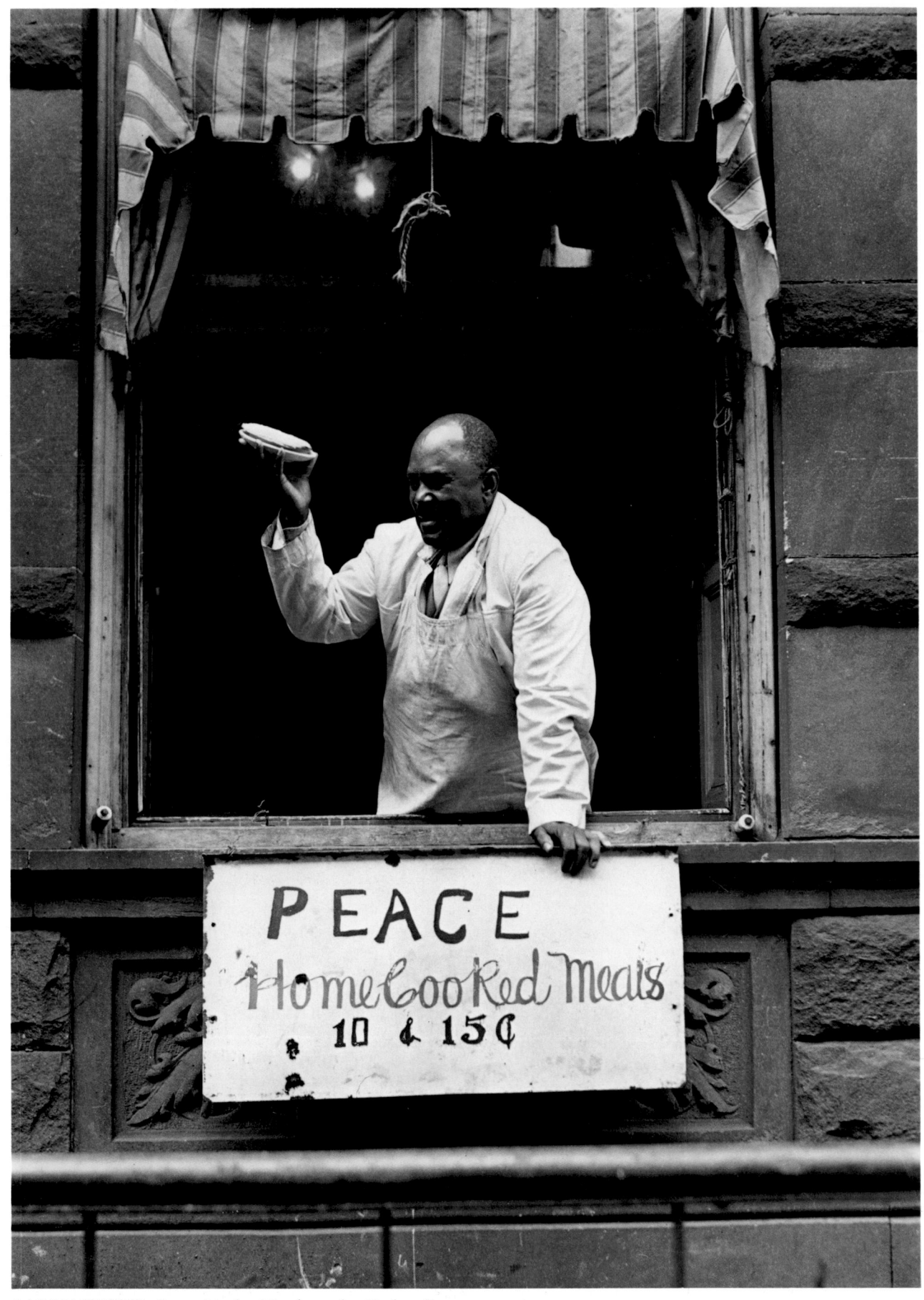

AARON SISKIND, Peace-Meals, 15¢, from the *Harlem Document* series, 1937–1940

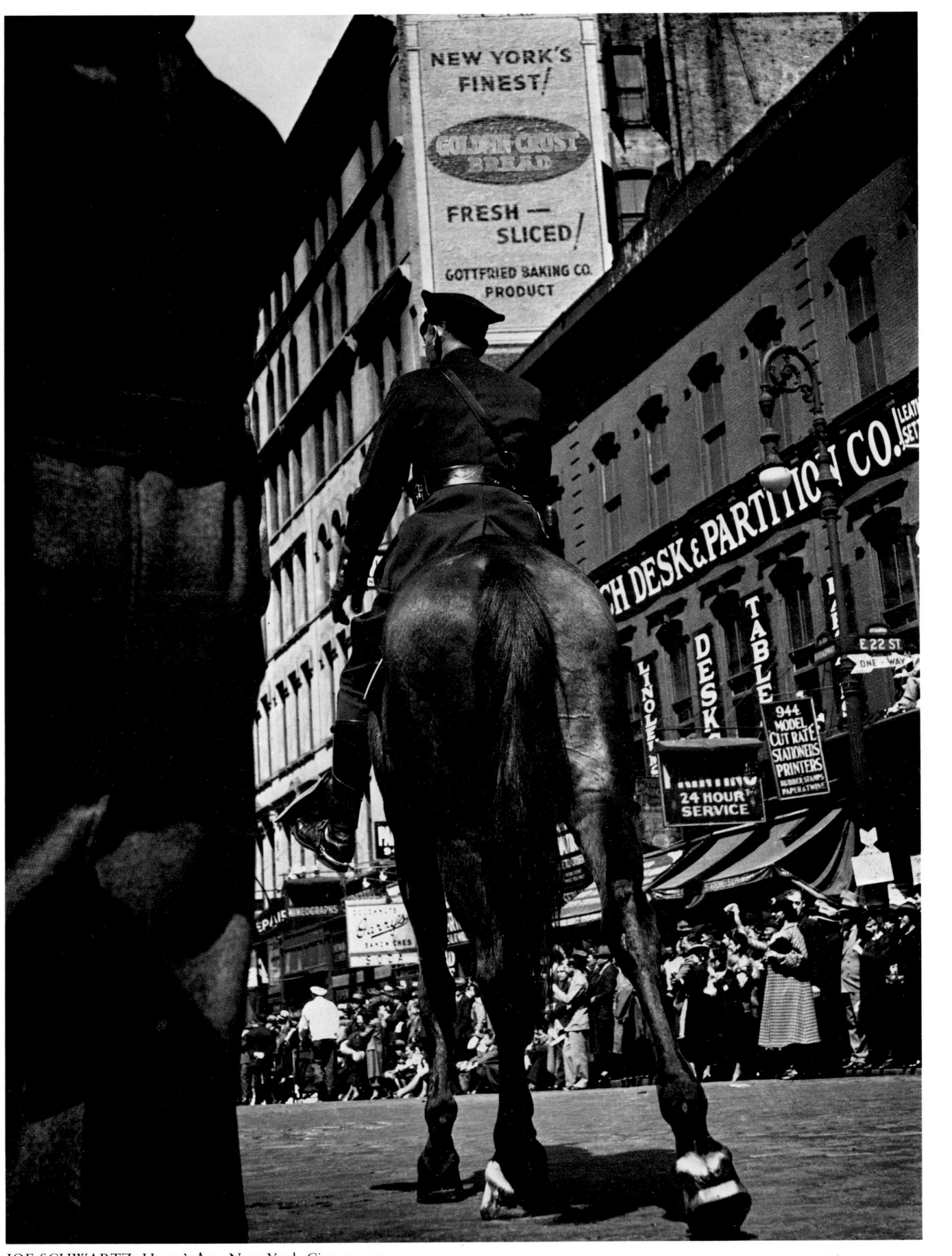

JOE SCHWARTZ, Horse's Ass, New York City, 1940s

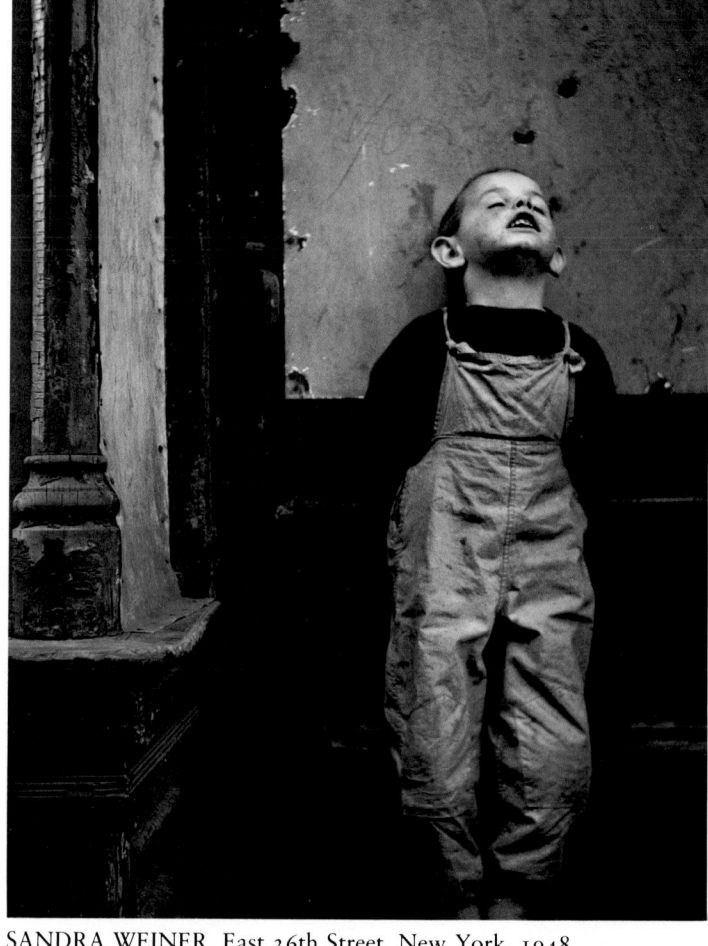

SANDRA WEINER, East 26th Street, New York, 1948

with it, that's another matter! I was not ready until 1915. Before that I was just groping, trying to feel my way. I would ask myself, what do Picasso and those other painters mean? Why do they do it that way? Why?

I would say three important roads opened up for me. They helped me find my way in the morass of very interesting happenings which came to a head in the big Armory Show of 1913. My work grew out of a response to first trying to understand the new developments in painting; grew out of a very clear desire to solve a problem. How do you photograph people in the streets without their being aware of it? Do you know of anybody who did it before? I don't.

Strand never conceived of photography (no matter how great his respect for esthetic craftsmanship) as separate from life and its social problems. Here we come to one of the most important, overlooked contradictions in creative photography. Camera, film and development follow objective scientific laws, but the final picture is essentially a *subjective* interpretation of reality. The photograph inevitably tells us as much about the photographer as the subject matter. We are what and how we photograph. A photographer who sees his or her photography as separate from and out of the mainstream of human activity runs the danger of falling into serious estrangement, from which it is difficult to create and produce. Not only did Strand see himself vitally concerned, but I believe it is to his great credit as a human being that he fearlessly fought (often with his photographic skills) the political evils of his time. He courageously entered the area of struggle on the side of the progressive forces.

From Photo Notes, *January, 1948:*

On December 4, 1947, the special board appointed by president Truman to examine the loyalty of federal government employees released to the press a list of "totalitarian, fascist, communist or subversive" groups prepared for its guidance by attorney general Tom C. Clark. On this blacklist, together with the communist party, the Ku Klux Klan, and such organizations as the civil rights congress, the joint antifascist refugee committee, and the veterans of the Abraham Lincoln Brigade, the Photo League was astounded to find its own name.

On December 16, a special meeting of league members to discuss what action the league should take was held at the Hotel Diplomat, and Paul Strand was the keynote speaker. In a passionate address he championed the role of the artist as an advocate for the individual's voice in society:

. . . . To silence you, intimidate you, make you think before you speak or not dare to think your own thoughts, but to go along with something that people are not willing to go along with—these are the objectives of the reactionary forces existing in our country today. My feeling is that Americans, if they know the truth, have good instincts of fair play, and don't want to become cannon fodder in an atomic war.

The methods of reactionaries are not new. The chief one

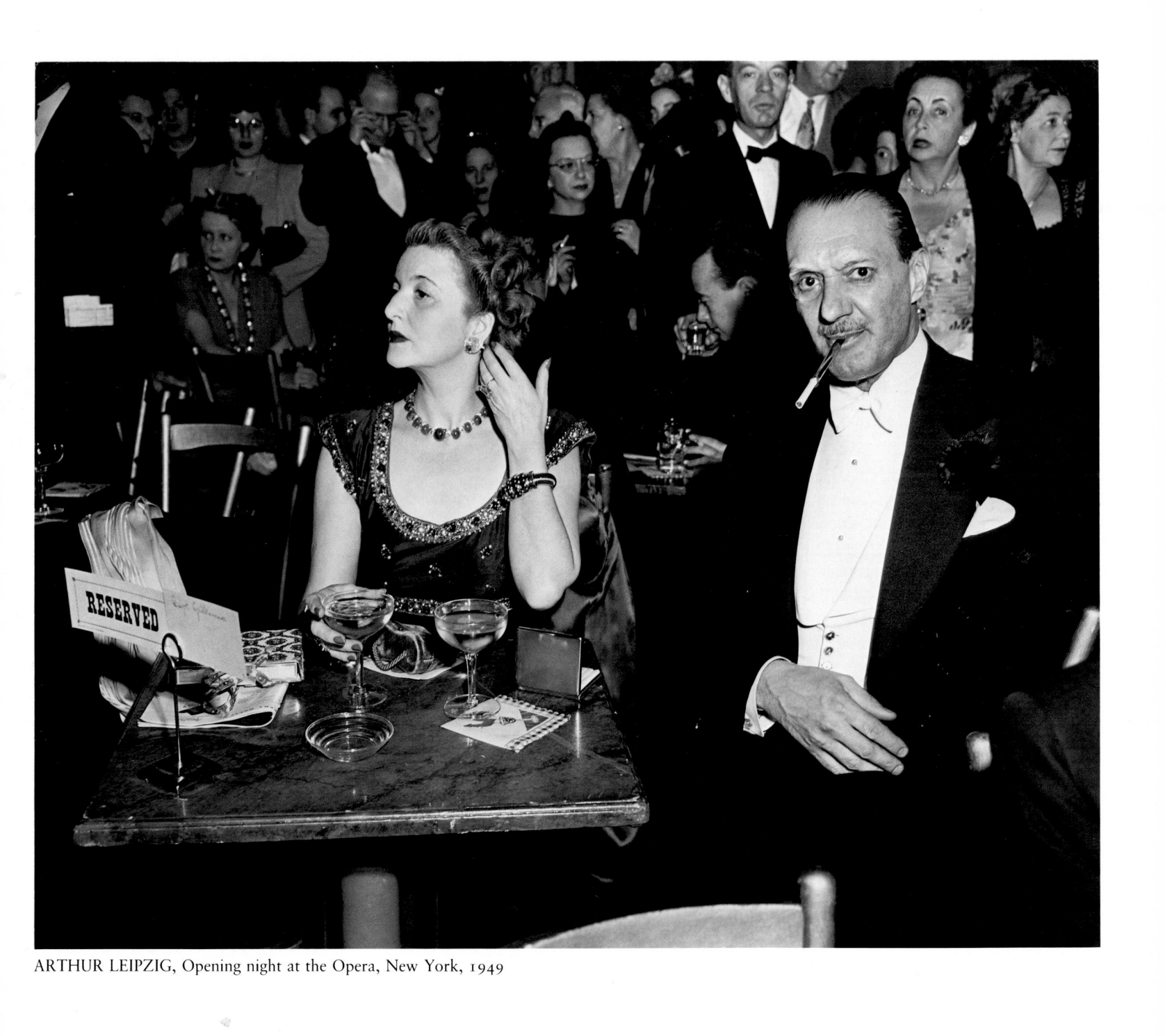

ARTHUR LEIPZIG, Opening night at the Opera, New York, 1949

Let us not forget what Stieglitz was photographing when he took "The Steerage." Dressed in spats and white collar, a first-class passenger pointing his huge Graflex into the grimy and dirty hold, Stieglitz saw those "masses of downtrod humanity" eating and sleeping as closely together as cattle. It is a deeply human photograph and indicative of the profound contradiction in Stieglitz which tormented him the rest of his life.

Looking back at his career, he seemed to embody two major photographic identities in his life. The first was from the pre-World War I era. During that time he was the active, outgoing person, photographing everywhere, publishing and exhibiting the works of other photographers—in a spirit very similar to that of the Photo League, had it existed then! The second Stieglitz, after World War I, turned away from the world, becoming ever more inward and introspective. He restricted his photography during the remaining thirty years of his life to views from his gallery window, to the immediate vicinity of his summer home in Lake George (also a cloud series), and to portraits of his artist friends (all very personal, significant photographs). His inward retreat can only be understood by appreciating the brutal shock given him by the World War I holocaust.

Prior to the slaughter of 5,000,000 people, Stieglitz's ideological position was that artists were not just important, but that somehow they could quite effectively change the world. Then there was the war, the Great Depression, and finally, World War II. Stieglitz's reaction was not to pitch in to the struggle and join the progressive forces (unlike Paul Strand, who spent ten years fighting fascism), but to create in An American Place a spiritual haven for his painters and a few photographers, as well as a spiritual force. Oddly, his dedication to creative art and wholehearted belief in its possibilities influenced Paul Strand and the rest of the Photo League.

It must be remembered that around the turn of the century painting and photography were often used to convey a sentimental vision of the world, not as means to find great spiritual significance in reality. This was especially true with photographs employing soft-focus techniques, in the footsteps of Impressionist painting. It is regrettable that Stieglitz and the Photo League never could get together, since right to the very end they had more in common than they realized. Both looked to a Whitmanesque spirit for what they could exalt rather than condemn (with Stieglitz, it could be clouds; with the Photo League, urban working people). As Stieglitz was quoted as saying in *Alfred Stieglitz: An American Seer*, "Just as I love when there is a rightness in loving for me, so I photograph when I have a positive reaction to what I see. Otherwise, I am silent."

Another major figure of American photography in this period, and the central pillar of the Photo League, was Sid Grossman. An original photographer as well as one of the great teachers of our time (he was head of the League's Photography School), he passionately believed in photography as a fine art and en-

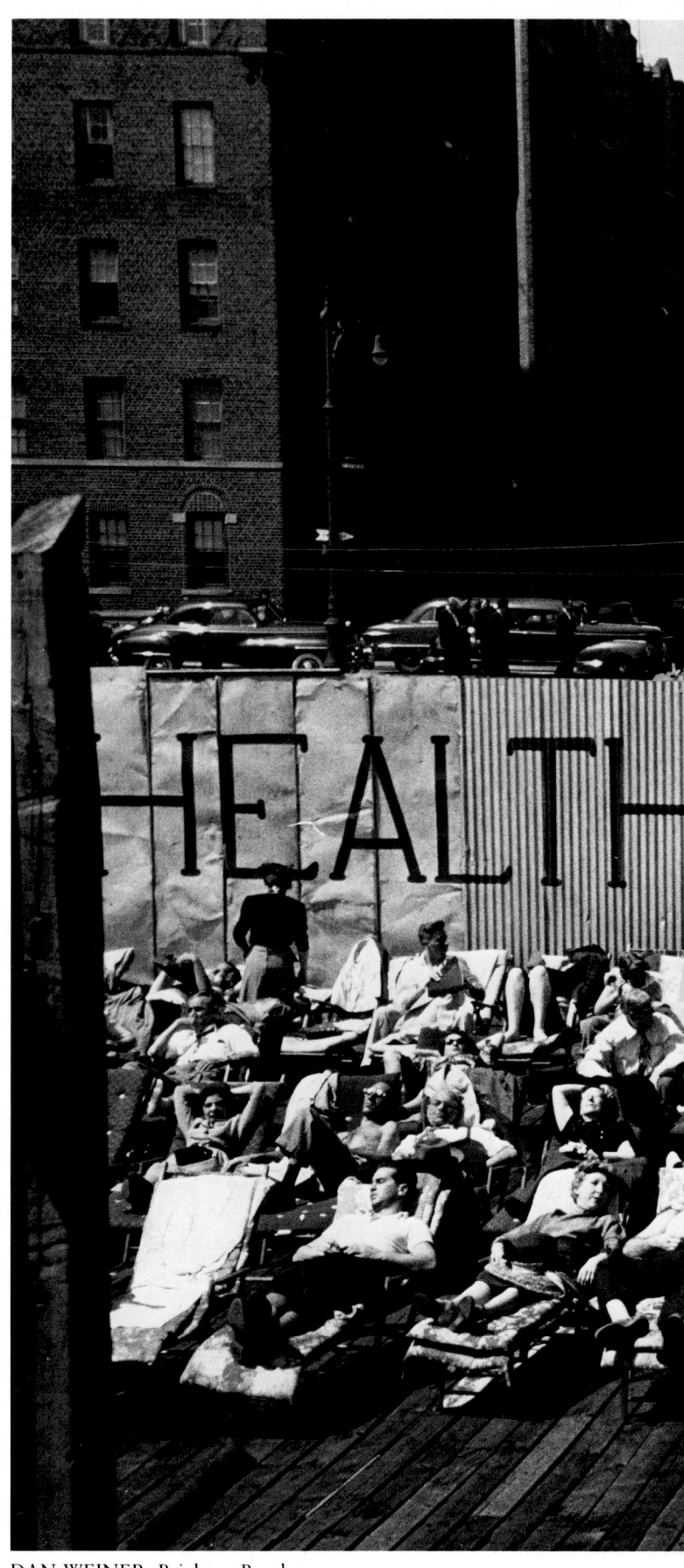

DAN WEINER, Brighton Beach, 1937

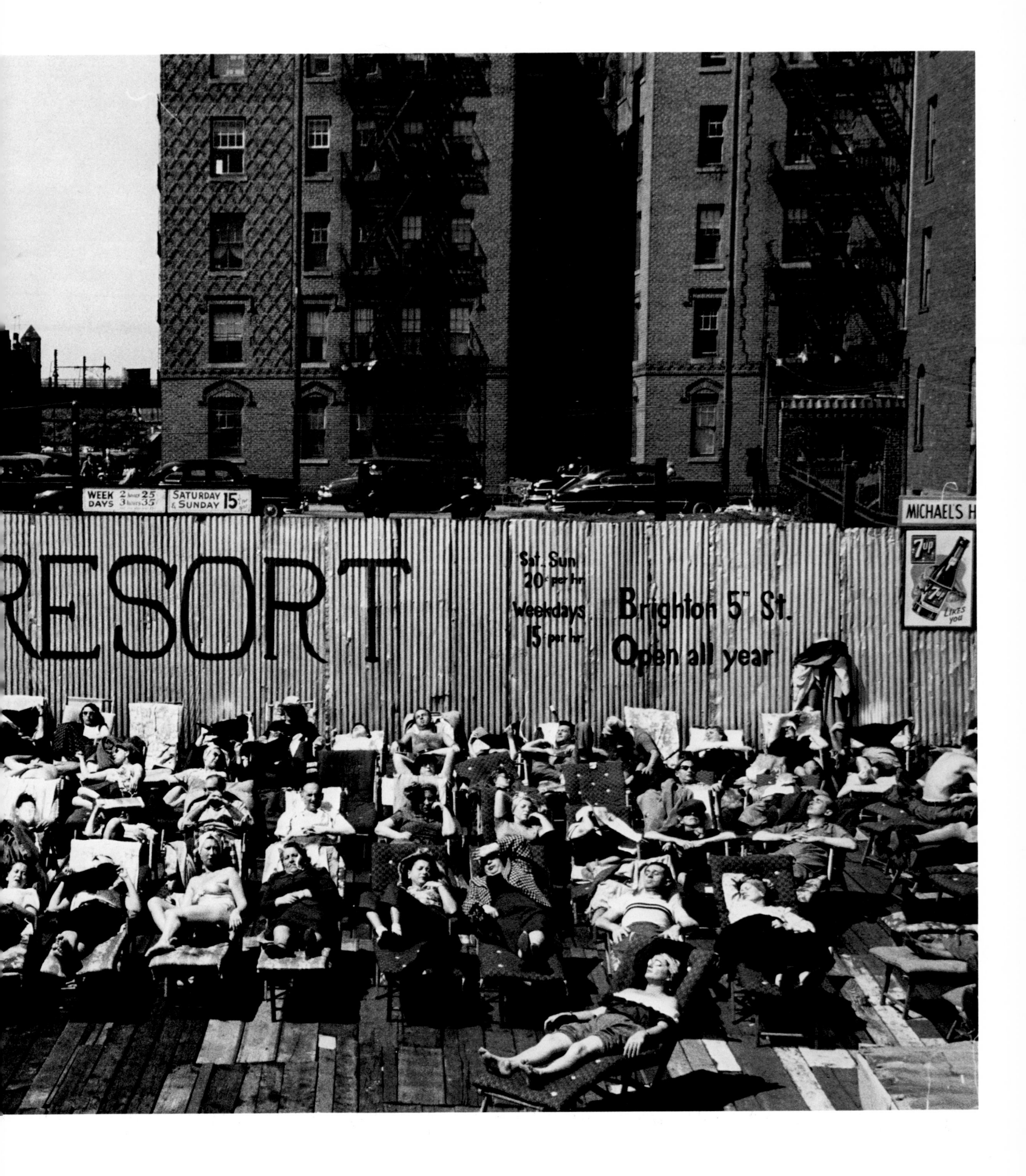

couraged everyone around him. Sid's often heated discussions about photography more than took the place of Montparnasse café-life as a clearing house for ideas about art. I will always be grateful to him, a loyal friend. He believed in me as a photographer (a belief that never wavered) when I was just starting out, and appointed me a teacher of photography, the youngest the League ever had. I cannot think of a worthwhile photographer of the time whom one did not meet at his apartment. (I remember, in particular, one time when Nancy Newhall dropped by to clear up a point about printing values with him.) Needless to say, he had certain ideas and concepts about photography that were not fully shared, and gradually evolved into what can only be called a Photo League approach to photography. In that view, the photographer was not a law unto himself, but rather, a responsible social being, with obligations not only to subject matter, but to the people engaged in the mass struggles of our time. The Photo League members saw the photograph as a raw but vivid experience of what was most vital and significant between photographer and reality. While they extolled photography as the art form of the twentieth century, they did not see it as an isolated medium, but one enriched and broadened by social and political involvement. Sid believed that a photograph is important to the extent that the photographer becomes emotionally or passionately moved by reality. He felt that only on a basis of emotion could a photographer come to grips with what was around him, and wanted to see that emotion in the final photograph.

The League taught me that the real impetus for historical change did not come from moguls of entertainment or industry, but rather, from the real life-force of people themselves. At the same time, it cautioned against idolizing the people and seeing them as quaint or picturesque, encouraging instead a profound give-and-take of feeling between photographers and their subjects. It frowned upon taking pictures of so-called "bums" or derelicts (today we call them street-people) sleeping or passed-out on the street (though it was a subject dear to Weegee, nevertheless). You will rarely see such photographs in League work—it was considered trite and overdone, bordering on needless sentimentality (what the French call *miserabilism*).

Sid had a profound belief in humanity. "You must know that people can enrich you and you them," he once said. A good part of his extraordinary development as a human being, teacher, and photographer can be traced to his strong conviction in humanism as a primary source of inspiration. He had a faith in the creative potential of people and in their ability to solve critical problems. It was this same faith in his students that brought out the best in them.

Sid's organizing activities were also based on his grasp of a fundamental truth that only a few photographers realize today: that it takes gifted photographers *and* a sympathetic, aware public to produce great photographs. Even the most talented photographers have to be encouraged by responsive and qualified people if they are to develop. Sid realized all too well that his own growth as a photographer depended on such contact.

His photographs also embody his unusual theories and techniques of printmaking. In order to highlight the intended emotional content, he believed in pushing the possibility of the print to the most extreme limits, and even went so far as to use potassium ferrocyanide in the process. When all possibilities of paper contrast, dodging, or burning-in had been exhausted, he lightened shadows, or brought out certain detail with the use of ferrocyanide. He also used "new coccine," a dye applied directly to the back of the negative with a brush, to lighten shadow areas. Naturally, these techniques gave him greater control over tonalities of the print than did straight printing, and these same formulas were to be adopted and developed by Eugene Smith.

Sid Grossman's background was unusual. Most Photo Leaguers came from middle-class families, but Sid, like Weegee, came from the poorest working class. His father was a ditchdigger. I remember him telling me of the bitter poverty experienced by his family, who went with hardly anything to eat for months at a time (this was before welfare and unemployment insurance). Sid never graduated from high school—he was that very rare bird, a self-taught working-class intellectual. From his working-class background, he brought to photography a realism about life and a compassion for and loyalty to those who worked hard. Early in Photo League days, a lasting friendship developed between Sid and Charles Pratt, a fellow photographer, former student, and millionaire, whose family owned part of Standard Oil and founded Pratt Institute in Brooklyn. It was touching to witness their friendship, based on mutual affection and their common love of photography, overcome all those class barriers. After Sid's death, Charles Pratt was to publish *From Here to the Cape*, a tribute to his friend's life and photography.

In his last years, Sid spent every summer in Provincetown, photographing the ocean and surroundings. This retreat in his life came after a harrowing time, when he and the Photo League were mercilessly persecuted by Senator Joe McCarthy and the other red-baiters of the early fifties. Despite his tough, Lower East Side manner, Sid was a very sensitive, shy human being, who, after this ordeal, could no longer approach people in the street with a camera. Turning to the beaches and ocean of his beloved Provincetown, he was working on this series of nature images when he died of a heart attack in 1955. On many levels—through his photographs, his work in the Photo League, and his influential relationships with many photographers—Sid Grossman left an important legacy in photography.

Weegee was another strong figure associated with the League—albeit in a curious, ambivalent way. The League was the first to recognize his work, giving him his first one-man show. In 1940, when Weegee started to work for the liberal

newspaper *PM*, where he was treated royally (with a weekly stipend and the first by-line ever given a newspaper photographer in American journalism), he met several colleagues, such as Morris Engel, who belonged to the Photo League. Whenever he came to League gatherings, he was sure to receive a healthy dose of hero-worship or just plain attention which he adored. The trouble was that Weegee could never quite get over his years as freelance photographer, during which time he engaged in a fierce competition with other photographers. Having always functioned alone, he was wary of any comradeship with his fellow photographers. (Our own very close friendship was confirmed only when he fell sick once in Paris, and my girlfriend and I looked after him for a few days. This was something he never forgot, often declaring in exaggerated fashion that I had saved his life. After that, he was a loyal and true friend for twenty-five years.)

Weegee was somewhat anti-intellectual, leery of any kind of discussion about the purposes of photography, referring to those who engaged in such analysis as "egg heads." Having quit public school at an early age, he felt insecure when too many sentences with ideas flew around. Nor could he share the often lofty ideals and optimism about human nature expressed by Photo Leaguers. Weegee, used to daily murder, rape, arson, and almost any kind of human evil, somehow managed to remain a humanist—but he retained a healthy skepticism withall. Of course, Weegee was not without principles: I remember his declaration (at a big financial loss) to have nothing further to do with an editor who had once paid him ten dollars a photograph, but who cut a print in half and used it twice without payment or acknowledgment.

It was particularly interesting to watch the relationship between Weegee and Sid Grossman. Both came from the same background, New York's Hell's Kitchen, and both left school to work at an early age. They understood each other only too well. In 1944, with the publication of *Naked City*, Weegee became an overnight celebrity, with Park Avenue society women practically begging to ride around with him in his news car at night to cover stories. He grew sarcastic about his fellow photographers and the Photo League, and though most of us at the League were amused and indulgent, Sid never quite forgave him—he saw Weegee betraying his own past, and the class to which they belonged. He accused him of allowing his head and soul to be turned by success and easy money. Unfortunately, much of what he said was to prove true: Weegee went to Hollywood expecting even greater fame and fortune, and instead, for eight years, produced nothing photographically worthwhile. (Weegee himself told me he considered *Naked Hollywood* to be very bad.) He humiliated himself in bit-roles, caricaturing the very people he had so wonderfully portrayed in *Naked City*. It took him years to return to New York and become his old self. Later on in life, after the Photo League was destroyed by

McCarthyism, I never once heard Weegee speak a bad word about the League. Oddly enough, he came to share much of its humanism. I heard him once comment with compassion about his photograph, "Summer, Fire Escape" (children sleeping outside to escape the terrible heat of the slums): "Those tenements are gone now, and thank God!" Perhaps, in some ways, Weegee also understood the truth: some of the League liberals, who supposedly shared high ideals with Sid and the rest of us, were the first to run when the witch-hunt turned on us.

It is true that the very-successful and those firmly part of the establishment tended to have very few contacts with the Photo League. Among *Life* magazine photographers, Eugene Smith (himself a rebel there) was the only one to regularly stay in touch with the League. And once, Eliot Eliofson did come to the League to give a lecture on his African shooting safari, during which for some reason he went into bizarre detail about leopard-tracking and droppings. More regular contact was kept with those from abroad, like Manuel Alvarez Bravo and Henri Cartier-Bresson, who realized the Photo League was a vital hub of photography in New York.

Any human endeavor has its shortcomings, and the Photo League was no exception. Looking back, it strikes me that at times meaningful content was given too much precedence over original esthetic form. Banal treatment was tolerated if the subject matter was right. The Stieglitz and Strand traditions, besides their considerable positive influences, overemphasized printing technique while ignoring the necessity for original inner structure in a photograph. Similarly, formalized repetition of subject matter was so prevalent that it practically became necessary for photographers to take pilgrimages to the Lower East Side of New York City. Perhaps it was not possible at the time—all efforts had to be focused on the immediate tasks—but it would have been more meaningful to have a broader cultural and historical base. Many of the solutions to the photography problems at the time would have been enriched by a study of early American photographers, European painting, the Bauhaus, and contemporary American painting almost religiously ignored by the Photo League. The one theoretician among us, Elizabeth McClausland, said much that was valid, but not broad enough in scope. We tended toward a narrow specialization that was never enriched or redefined by the photographers themselves as they progressed in their work. By contrast, Stieglitz and his *Camera Work*, encouraged numerous credos, manifestos and statements of position by art critics and photographers. But these criticisms are minor.

Oddly enough, the writing on the Photo League has focused most accurately on its demise, so much so that the story hardly bears repetition. The Soviets exploded their atomic bomb, Truman started a furious witch-hunt, and the Photo League became one of its first victims. What has not been recorded was the terrible personal anguish inflicted on many members. Not only

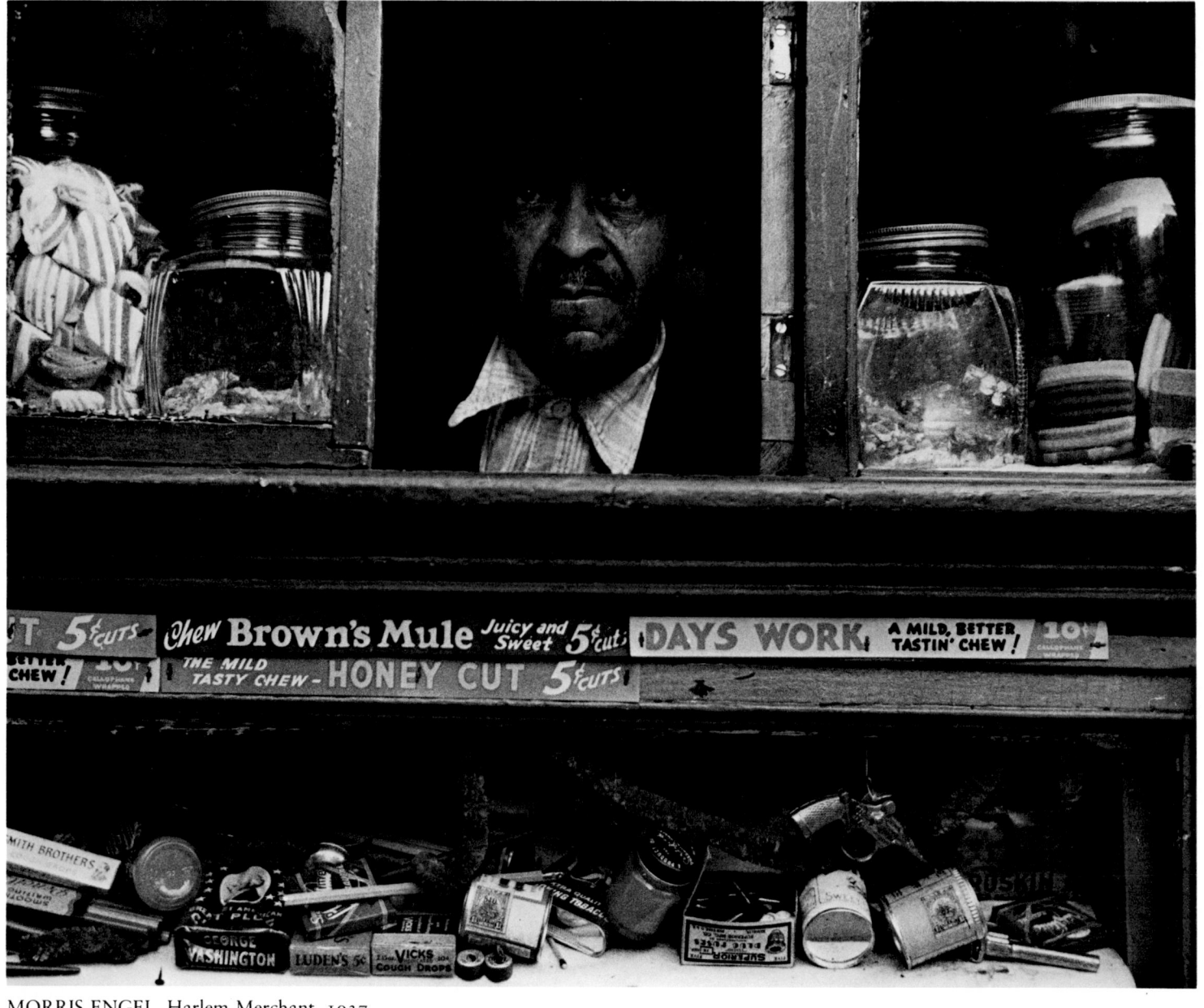

MORRIS ENGEL, Harlem Merchant, 1937

did many find themselves destitute, which was bad enough, but they also found themselves alone, walking down a street to find supposedly good friends not daring to say hello to them. Working in Paris at the time for a Marshall Plan project, I was called in one day to the local FBI office. I remember being struck by the agent's very long, flat, black shoes. He showed me a document recording my association with the Photo League, and asked me for the names of communists in the League. I said that not only were my fellow Photo League members friends, but whatever political affiliations they might have was for them to divulge. The discussion ended. Once back at the office, I was told I could no longer work for the Marshall Plan. Since I knew

I could live on very little in Paris, I did not mind very much—French bread and cheese were very good and the *vin ordinaire* was better than anything I could get in New York. However, money for paper and film was a problem. What puzzled me was an unanswered question: where was the freedom I fought so hard for as a combat photographer in World War II? U.S. officials could become very mean when they encountered anyone who suggested to them that there could be an economic system that might work better than capitalism. I saw the FBI man a few days later near the American Embassy carrying a very large bag of groceries from the PX exchange. To my surprise, he nodded hello. I thought I detected a certain respect—much like

that of the executioner who compliments a particularly brave victim. His long black shoes struck me as even longer than before.

Photo Leaguers were also very partial to their subject matter, America's working people in the urban environment. They did not approach their subjects objectively, but subjectively, with a passionate belief in their qualities, dignity, and ultimate worth. It is these characteristics that distinguish Photo League photographs.

The Photo League experience relates to today's contemporary photography in ways which underscore its unique character and importance. Starting in the late sixties, photography as a fine art began to blossom in the universities, galleries, and institutions. By the early seventies, photography had become, in the words of Paul Strand, "a salable commodity, and I suppose on the whole this is a good thing." Perhaps, but a number of negative tendencies have since developed in photography, not the least of which has been an almost complete break with the humanist-realist tradition as expressed in the Photo League.

The new art establishment, for the most part, encourages "belly-button" photography, claiming the photographer's inner vision is everything, and reality something that can be manipulated at will. Humanist realism does not deny the primary importance of personal vision, but it does not attribute *everything* to it. Academia has encouraged photographers to ignore political and social content and to concentrate on form. They call this formalism. (I call it self-indulgent estheticism.) Less serious photographers will concentrate on the corners of rooms or gimmicks or handles that are glitzy and fashionable. As a result of the McCarthy period and the Vietnam War, academics were told in no uncertain terms to keep out of politics and to stay away from the real world, a warning that, in general, has been well-heeded. Today, most photographers (expressing their own estrangement), portray people as lifeless puppets or helpless victims of a system they can neither understand nor change. Writing about early twentieth-century art, the English critic Alistair Mackintosh pointed out: "It is an ironic truth that the moment when art claims to be "above" contemporary life is always the moment it becomes controlled by it." The separation of human vision (including artists) from its social, historical, and cultural context represents a phase that art has passed through before. It is called anticlassicism. As Walter Friedlander states: "The whole bent of anticlassic art is basically subjective, since it would construct and individually reconstruct from the inside out, from the subject outward, freely, according to the rhythmic feeling present in the artist, while classic art, socially oriented, seeks to crystallize the object for eternity by working out from the regular, from what is valid for everyone."

The current anticlassic style in photography is also due in part to the huge wave of consumerism that began in the late fifties. Introduced as a mass medium in the early fifties, television has gradually become overpowering and overwhelmingly effective. During the Photo League era, the average American still had strong social ties to the community and the work place. Recreation and entertainment were, for the most part (though there were also movies), tied to activity in the immediate environment, and not to the world of the TV tube and the all-pervasive, authoritative voice of the establishment. Much of the appeal of Robert Frank's 1958 book of photographs, *The Americans,* is its emphasis on the growing sense of the individual's helplessness before a system that he could neither control nor comprehend. It correlated directly with the American intellectual's growing sense of despair.

Entertainment TV changed the very content of fine art: the artist was expected to be an entertainer. TV's bright colors, tricky images, and high-tech illusion postulated that life is essentially witty, funny, and worth living. Eventually crime, murder, drugs, and poverty could be portrayed as easily digestible—and even entertaining—commodities. The mass media fashioned the artist as a sort of visual performer whose function no longer was to spiritually nourish, but to entertain his audience. The high prices and quick fame offered by Hollywood, slick galleries, and well-heeled publishers only accelerated this image. Here and there, though, genuine art is being done—there are a few receptive galleries and institutions. Yet, sometimes protest can take strange, devious paths. The photographs of Joel Peter Witkin, which in some respect are examples of explosive pornographics, express vividly, in their most positive sense, the frustrations of a photographer unable to relate to his world.

This is not to rule out subjectivity. After all, things are seldom the way they seem. An apple is never just an apple to an artist. But the point is that some artists strike a resonant balance between the interior and exterior worlds. Several years ago in *Art News,* a critic quite rightly pointed out that Cezanne's apples were not just his own personal interpretation of apples; they were also enriched by Cezanne's affinity and deep appreciation for the French peasant. They embodied the hard toil and patient care of the working man. Cezanne's apples reflect not only the beauty of nature but also man's effort to nourish and transform it. By giving political content to his apples, Cezanne raised them from being "nice" academic still lifes to statements of great beauty and meaning.

The Photo League was part of the humanist-realist tradition in photography which goes back through Strand, Stieglitz, Hine, and David Octavius Hill. It is a vision based on interpreting the world around us, focused on human beings in their society and culture—the prime motivating force in this universe. The Photo League was a unique group expression of a profound humanist thrust in our century which immeasurably enriched American culture. It has been my good fortune to have been part of that experience.

Looking for Mr. Winogrand

By Helen Gary Bishop

"I'm so fuckin lucky . . . my work, I love it. I've had my share of success . . . my kids, they're wonderful, the greatest. I can't figure it out, ya know . . . like, Why Me? Shit, I spend my time waiting for the other shoe to drop."

It did. In 1984 on your way to Tijuana. This time you didn't bring your camera. Traveling was no stranger to you, the natural state of a man with "three motors, all in second." Your astrological sign could have been Motion—you came close to it with Capricorn, the mountain goat and satyr, climbing, leaping, always challenged by a higher, sharper peak. Patience and moderation were words you couldn't understand.

Even as an eleven-year-old you'd leave the apartment and roam the Bronx, alone. When you got back you'd catch hell. While your father watched with that melancholy look of his, mother yelled, threatening unspeakable retribution.

Mother. A fury with occasional lapses into affection. From birth you were incompatible. She couldn't nurse you and turned you over to Aunt Rosie who had enough milk for a Boy Scout troop. Aunt Rosie's sweet, generous breast was something you never forgot. Your mother was jealous (even though she preferred your sister Stella.) Not quite kosher, now that you think about it, for the first-born son, the prince in the eyes of all Jewish Mothers. Stella was a good girl with manners, common sense, someone Mother could impart real values to. Not like you, unruly, Smartass, chafing at the bit, one eye on your food and the other on the door.

"We lived in a smallish apartment, the four of us. We weren't rich but we never lacked for anything, not us kids, anyway. Ya know, I wanted to do something, they had the money for it, nothing extravagant, but I could do what I wanted to do. Dad was a leather-worker, a quiet guy. Mom made all the rules,

GARRY WINOGRAND, Adrienne, c. 1960

GARRY WINOGRAND, Laurie and Ethan Winogrand, c. 1958

GARRY WINOGRAND, Ethan, c. 1963

had all the answers. She worked too, piecework, making ties. She was good with her hands. But any minute she could cause a catastrophe. Like I'd be reading a book (I read a lot) and I'd look up and find that my mother had put the fuckin metal fish tank on the radiator. I loved those fish . . . I fed them and gave them names . . . the whole bunch, belly up. How does a kid deal with that kind of chaos?"

Mother was a kvetch, never satisfied, forever wary, resentful, with "physical problems" requiring doctors, surgeries, medications, special diets. All the perfect foil for what could only be described as NEED FOR ATTENTION. This said, she was a ball of energy right into her eighties. She never understood what your work was about. "What's this, taking pictures! Why can't you get a real job like everyone else? Like your sister's husband . . . a Business Man, a REAL man." Once at one of your openings someone went up to her to compliment you. You must be very proud of your son, this person said. "I'm proud of ALL my children," she said. She was not easily duped.

During your early teens a majestic event took place. Somehow you got picked to be an extra for the Ballet Russe de Monte Carlo production of *Gaité Parisienne*. For a buck a performance, you were bused to Manhattan, and wearing a painted mustache and a false beard, you impersonated a musician in a small on-stage bandstand. From close range you breathed the perfume of female flesh. "All those ballerinas, the costumes, the way they did themselves up, Jesus . . . and all those thighs. Shit, I never got over it, I swear." And you never did. Circus artists, majorettes, burlesque queens or simply culture-strutters at arty openings, "women who design themselves" were to be a constant source of fascination.

When the Ballet Russe, Sadlers Wells, and the Roland Petit ballets came to New York, you became a ballet groupie. Somehow you got backstage in the wings to be there as the ballerinas swept past. . . . Sooner or later someone figured out that the

GARRY WINOGRAND, Ethan, c. 1962

GARRY WINOGRAND, Adrienne and Laurie, c. 1961

ogling kid didn't belong there and you were kicked out. No matter. For a precious moment, the real world was very far away.

After high school the fastest track out of the house was the army. In 1946 you took the tests required to join the Intelligence Service. You passed them all except one—Security! That's when you found out your father had entered the U.S. illegally from Hungary. You were amazed that he had never told you that exciting story. It occurred to you that he might have been ashamed of it. You ended up in the Weather Service. One of life's little jokes.

Discharged because of an ulcer (which you had when you passed your physical) you enrolled in painting classes at Columbia University. No great conviction in this choice, you just wanted to take advantage of your GI Bill benefits. But you did have a gut feeling that life's unremitting drudgery and sense-lessness could be redeemed by art. Perhaps you thought it was your only route to salvation. "I'm kind of a weak person, ya

know. I needed something bigger than myself to live for, some ideal, ya know what I'm saying? I mean I think I could've ended up a junkie, or a criminal, or anything. Like if I'd had any kind of a voice I would've tried to be a singer, ya know. So I stumbled into photography and I jumped right in. Never looked back. Threw myself into it for dear life."

Two weeks into painting class a friend told you about the all-night darkroom on campus. You discovered the magic of the developing process, making images appear from nothing. You dropped out of classes, devoted yourself to photography with a kind of obsessive energy. You lost the GI benefits and you found the camera of your choice—the Leica.

You carried it with you like a heartbeat. You bought military surplus film for a buck forty-nine and you took pictures, and pictures. A few rolls before lunch, during lunch, after lunch, on the street talking, walking with friends, from the bus, from inside buildings. The people and landscape of New York. You liked the vitality of the streets. You knew that the most mundane moment could be charged with drama. That knowledge made you an artist.

"Those were exciting times for me. I was working my ass off. Taking pictures, developing them at night, editing them, learning more with each roll, discovery after discovery . . . shit, what a perpetual high. With the guys every day, talking pho-tography, studying the work of past photographers. Christ, no college education could've given me what I got then. I was scratching after jobs, picking up the regulars' crumbs. And was I poor. My father would slip me a few bucks every now and then. My mother! She just thought I was bumming around, going straight to hell."

You met Adrienne, a dancer. She was only fifteen-and-a-half. You liked being the experienced "older man," it gave you a sense of security, power. Two weeks after meeting her you called up and asked her to marry you. She wrote a long letter, carefully explaining that she wanted her own career, she wanted to dance and to choreograph. You pursued, determined that a ballerina would at last be yours. You went to see her at the dance studio, you took pictures of performances, rehearsals, dressing rooms, of her dancer friends making up, putting on costumes. This time you were part of the scene. No one was kicking you out.

You went to see foreign films and discovered the stark power of Italian *neorealismo*. You studied the French photographers—Cartier-Bresson, Lartigue. You felt uneasy about the artfulness of these giants—Atget and Brassai were closer to your feeling that the photographer should stand back and let the subject speak for itself. "No picture should be more interesting than its subject" was the way you put it. "A photographer should not be overwhelmed by the possibilities of his camera." You cultivated a tight group of New York photographer friends, your inner circle, your support-system. Your life became a daily ritual—a few hours' sleep in the morning, afternoons with the guys rapping about photography and sex, the evenings out

scouting for both, and the nights in the darkroom. You got to be a regular for the illustrated mags—*Collier's, Life, Pageant.* You start making a few bucks and thinking you could have it all.

Three years after you met Adrienne you convinced her to marry you. She agreed—if she could finish college. You had a wonderful big Jewish wedding. She was nineteen and you were twenty-four. The honeymoon was short-lived. For starters, you came home just as she left for classes. Assignments/developing/hanging out with the guys was how your time was spent. She had homework, picking up after you, and a part-time job. The money situation—hopeless. Your father helped with the rent. Your mother . . . well, let's say she reacted with her usual flair, butting in, telling Adrienne she was wasting her time with school. Why didn't she get a full-time job so you could concentrate on being a genius. The pressure was too much. Adrienne left.

You got her back but you couldn't talk to her, discuss things. Nor were you able to listen. You were never one to reveal yourself. And now your fear of intimacy was exacerbated by the agonizing over which way to go with your work—photojournalism for money or art for glory—were you even good enough to consider the latter. You, hyped up on endless quantities of caffeine, nicotine, and more than a little drinking. You stalked the apartment like a caged animal, you shouted, you ridiculed, you didn't express your love. In a word, you did it all wrong.

You discovered Walker Evans's *American Photographs* and Robert Frank's *The Americans.* You marveled at the transparency of style, the total absence of manipulation. Suddenly you knew what to do. You talked Adrienne into a cross-country trip by car. It's what your marriage needed and what your work needed. You'd see America for yourself. During the four months of the trip your marriage was privileged. You rattled around telling stories, composing little operas for each other, picnicking, and loving. All the while you took pictures.

Adrienne came back pregnant. You were thrilled. You had not a thought about the responsibilities or the complications a child would involve. Your daughter was born and you experienced pure joy for the first time. You took pictures of mother and child, tons of them. Soft-focus, grainy shadows and light, emotion-filled poems to the wonder of life. Despite another joyful birth of a son two years later, the marriage began to come apart. One day Adrienne took the children and left for good. A wound became felt that would stay with you the rest of your life.

"What the fuck do ya do? Ya come home one day and your house is empty. A stray toy where your kids used to be. Ya drop your guts. Your deepest fears of separations and betrayal come true."

You hurled yourself into shooting photos, the anodyne and the weapon. You drank more. You spent as much time with your adored children as you could. You got into their world,

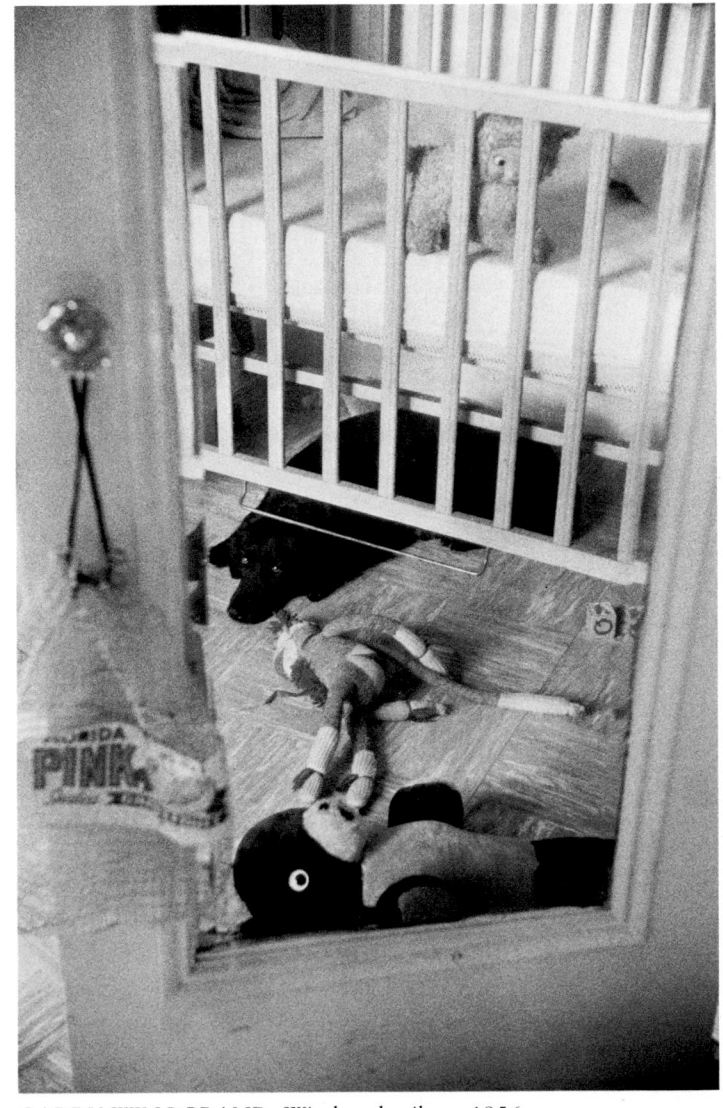

GARRY WINOGRAND, Wind and crib, c. 1956

the playgrounds, the zoo. You photographed the animals and the people watching the animals. The first of the shows at the Museum of Modern Art in New York in 1963 began to establish your tradition-busting style as the forefront of new American photography. In the meantime you moved from journalism to advertising photography. You were making enough money to live and support your real work.

You photographed women obsessively. You found women were sensitive to being immortalized by the great photographer. You flashed your Leica, no trenchcoat needed, and they offered themselves. It's the nubile creatures that made your shutter click. The sense of power was exhilarating, the insecurities about women disappeared. And if you were to tell the truth, the relief from domestic confinement was liberating. We're talking about the swinging sixties here. The New York cultural hipsters, as you liked to call them, invited you to come hang out.

"I'm at the Steichen opening at the Museum and I meet this girl. She was beautiful, I mean beautiful . . . the kind of beauty

I'm an easy victim to. I mean she's got the figure, ya know, but she's got this face, too . . . Well anyway, I got her leaving with me and it's down to the line and all of a sudden she . . . ya know, I gotta laugh, I'm pissed, but I still gotta laugh . . . 'cause she says to me that she's gotta leave with the guy she came with 'cause otherwise she won't be able to face her analyst."

You traveled on your first Guggenheim fellowship in 1963 to Texas, Colorado, California, and back to New York to catch the World's Fair. You were invited to the White House and you went. You met Judy, a sophisticated commercial artist and for a while it looked like you were going to smooth out the radical edges and join the upwardly mobile. You married Judy and went off to Scotland, England, France. You realized in a way you never had before what it is to be an American.

"Ya know, people are always talking about the 'grace' of the European photographers. They're 'pictorial', they have a sense of order, of how things should be, ya know what I'm saying. But they don't know shit from spontaneity. I mean the real thing, not the scene that's supposed to look like it. Like your brother-in-law floating fully clothed in a tube in the river. Come on. It's simple, I'm interested in the clumsy, the grace that comes out of that, that's what fascinates me. As far as what a picture looks like, well, the U.S.A. is not exactly visual opulence. I mean, quaint old villages are not us. Seems like when things get old here, they get crappy."

You worked and learned the commercial world. You began to understand how media manipulates public opinion, and that disturbed you. You got a second Guggenheim to probe the effect of media on events. Your pals were always there for you, alert, watching for distress signals that don't fail to come. Marriage turned conventional and there was talk of winter vacations and summer houses. You separated from Judy. Another personal defeat rocked you, but you had your children for solace and your buddies who huddled to help you through. You went back to shooting women, only women. Lots of women. You told the boys you'd decided it was time to study the nude figure. In 1970 you joined the faculty of Cooper Union as professor, but only a year later you moved to Chicago's Illinois Institute of Technology, teaching workshops in Colorado and Arizona, traveling around once again. You returned to New York and married Eileen Adele, a young woman who had been one of your models. You taught at Cooper Union again, and took on workshops, lectures, guest appearances, and far-flung assignments. Like a shark, you couldn't stop moving. Your humor turned cynical.

"Ya know, I go to this swank party and I see this guy that I know. A conservative type, grey suit, the whole thing. Well, he's wearing this fat, flashy tie that's made of corduroy. That's right! Musta taken him an hour to tie this bulbous knot in it. So I go up to him, I say, 'Hey, where'd ya get that tie?' He smiles, like lights up. 'My wife got it for me,' he says. So I laugh like crazy, 'Yeah, I bet it was your first wife, right?' "

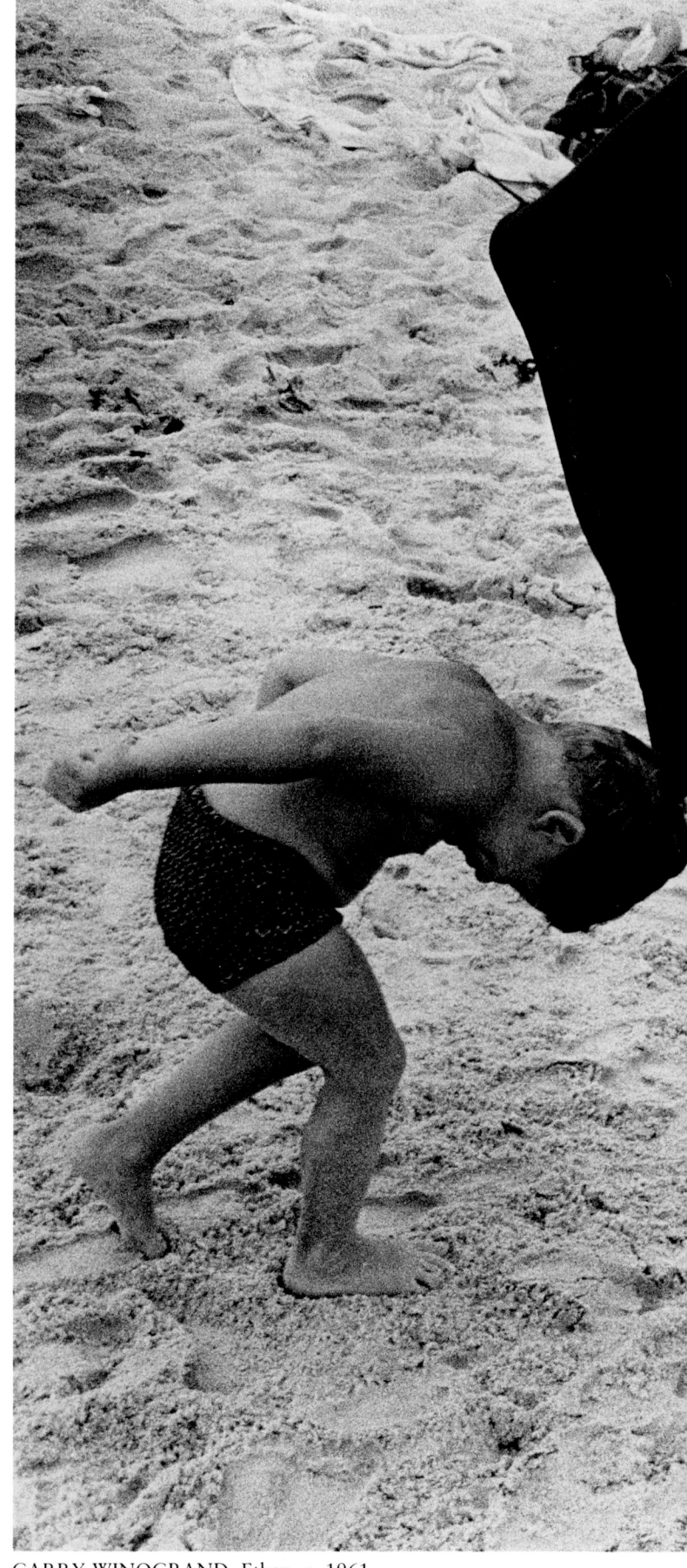

GARRY WINOGRAND, Ethan, c. 1961

In 1973 you did something inexplicable even to your closest friends . . . you moved to Austin, Texas, to join the faculty of the University of Texas. Word was out that your marriage was going through serious problems despite the birth of a daughter. Your friends urged you to come back to New York. Your reputation grew, you became something of a cult figure, "the image-maker of the '60s," but somehow it was the earlier work that was getting printed. You still took pictures around the clock but somehow the pace seemed less like energy and more like agitation. The flight forward acquired an urgency. In 1975 mo-tion came to an abrupt halt.

You stopped smoking (but not drinking nor eating the rich diet you always preferred) and gained fifty pounds. A thyroid condition became acute and an operation was required. No sooner did you recover than you were off shooting the Texas vs. Texas A&M football game from the sidelines. You were hit by three players, breaking your leg and shattering your knee cap. Even after months of recovery, you knew that you would never be the same. In 1975 you discovered your mortality.

In 1978 a third Guggenheim took you to California and you decided to live there. Cut off from your base, you seemed to have lost the acute sense of timing you are famous for. "I don't want to do 'pictorials'—I don't go in for shadow and light. My lighting is left open. A photo is a literary nar-rative . . . but it's not specific." Your life was getting less specific and no one was getting to see the recent photos to get a clue to what was going on. Your friends wondered . . . how in slow-paced California could a man whose every nerve vibrated to New York rhythms survive? Why didn't you come home?

Did you feel your strength abandoning you after the 1975 disasters? You could have taken care of yourself, readjusted,

there was still time. There were people who loved you, your children, your New York friends always near with phone calls and visits. Or was the truth darker yet—had you shot your load, said everything you had to say? Is that why you were so willing to cultivate the Public Figure, lecturing and teaching photography? You who in earlier days had said hundreds of times to thousands of students, "You wanna be a photographer, get out there and take the pictures. Then go develop and edit the pictures. Then do it again. No amount of theory is gonna make you know how to do it. That's bullshit."

During your six years in California you took more than a third of a million pictures—but you didn't develop, didn't con-tact, didn't edit them. You quite clearly were not interested in seeing what you had done. The pictures reveal a lack of con-viction, an absence of the energy that was your signature. You didn't even bother to hold the camera steady when you were shooting. A puzzling aspect to this collection is a series of shots of old men that come close to being simple portraits. Were they a return to the early portraits of your family or were they the horror of old age, defeat? And those of the elderly couples, startled in their aimless doddering by the intrusion of the cam-era—are they the grimace of love? Are they your ultimate in-dictment of marriage? You talked about returning to the East, a house on the Hudson. You said you wanted to try something new with an 8 x 10 view camera. Did you ever intend to do any of that? We'll never know. It's your secret. You never did explain the reasons for anything. Right to the end. To your last trip. You had agreed to see a faith-healer across the border in Mexico. Conventional medicine had declared you had incurable cancer. It was your only hope, your family said. Perhaps what you really hoped for was to be left alone comfortably in your room, your mind free to roam the Bronx of your youth.

One of your closest friends came out to spend a week with you. Now he had to go back. Your wife, your grown children and a California colleague stood silently by, waiting to take you away. Your friend took your hand. He didn't know how to say good-bye. He smiled weakly. "See you soon. Good luck." You wanted to say something to cheer him up, you who would do anything for a laugh, almost anything, "I'm off to fight the bulls," is what you said. But you knew you were really going off to join them.

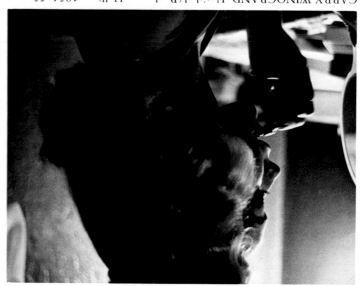

GARRY WINOGRAND, Untitled (Burlesque Hall), c. 1954-55

This essay is a portrait of a mythic Garry Winogrand, a twentieth-century archetype. It is based on researching taped interviews with the photographer, on conversations by the author with close friends and family, on published sources, and on impressions received from having met Winogrand personally. The historical data, descriptions of family members and quotations have been interpreted and focused through the lens of fiction to create the portrait of a man larger than literal description. Helen Gary Bishop

The family photographs on pages 36-45 are unpublished work from the collection of Adrienne Winogrand, selected for this memoir.

GARRY WINOGRAND, Untitled (Burlesque Hall), c. 1954–55

Memento Mori

It has now been four years since Garry Winogrand's sudden death, which cut short the life one of photography's most voracious eyes and vociferous voices. Now, the opening of the retrospective exhibition of Winogrand's work at New York's Museum of Modern Art offers the fullest memorial and appreciation of Winogrand yet seen. Curated by John Szarkowski, the exhibition will travel throughout the United States and abroad over the next several years, and is published in conjunction with a monograph *Winogrand: Figments from the Real World*, which marks the culmination of Szarkowski's long association with Winogrand, whom he called "the central photographer of his generation."

In the current retrospective, Szarkowski traces the course of Winogrand's career in over 200 photographs, many of which have not been shown (or published) before, demonstrating Winogrand's lyrical vision of the drama of public life in postwar America, found in the welter of the city street, in the dreary transience of strangers in airports, or in the arcane public rituals of press conference, football games, and rodeos.

In *Figments from the Real World*, Szarkowski provides a wealth of new biographical information about Winogrand's life, and weighs the significance of his work with a passionate but measured eye. In particular, he wrestles with the mystery of Winogrand's last years in Los Angeles when, as Szarkowski writes, Winogrand became "a creative impulse out of control." In the end, Szarkowski views both the life and the work with sympathy and admiration. "Winogrand," he argues, "has given us a body of work that provides a new clue to what photography might become, a body of work that remains dense, troubling, unfinished, and profoundly challenging." It is hard to imagine a more fitting tribute to this difficult and restlessly brilliant man.

THE EDITORS

GARRY WINOGRAND, El Morocco, 1955

GARRY WINOGRAND, Untitled, c. 1954–55

GARRY WINOGRAND, Untitled, 1950s

GARRY WINOGRAND, Floyd Patterson, c. 1954

GARRY WINOGRAND, Untitled, 1950s

GARRY WINOGRAND, Untitled, c. 1954

GARRY WINOGRAND
Austin, Texas
c. 1977–80

GARRY WINOGRAND, New York City, c. 1982–83

Since the medium's birth, intelligent photographers have understood the lens' demand that we cleave to the illusion of fact if the illusion is to be believed, that little room exists for doctoring one's material before it turns solipsistic or vague . . . Winogrand's pictures swath such rarefied associations in irony, delineating a voracious self behind the work. The pictures' power resides in the rootedness of their subjects in the world we think we know—the hungry viewer who reads beyond their suspended events in neither imputing nor projecting their further meaning . . . The ambitious young photographer who pays close attention to these pictures may imagine beyond them an idea of photography that the camera's literalism has warned its greatest artists not to proclaim. For this work has so refined the rhetoric of the lens that we may now read a questioning mind in photographs despite the absence of a tangible first person. Winogrand's work predicts a photography that might candidly undertake the venerable debate between imagination and fact, that might assign metaphors to things without embarrassment, and that because of the camera's intractable fidelity to surfaces, might consciously enter the ground of art's struggle between aspiration and one's place. LEO RUBINFEIN, 1974

GARRY WINOGRAND, Los Angeles, c. 1980–81

There is nothing as mysterious as a fact clearly described. . . . A work of art is that thing whose form and content are organic to the tools and materials that made it . . . Literal description or illusion of literal description, is what the tools and materials of still photography do better than any other graphic medium.

A still photograph is the illusion of a literal description, of how a camera saw a piece of time and space . . . I like to think of photographing as a two-way act of respect. Respect for the medium, by letting it do what it does best, describe. And respect for the subject, by describing it as it as. A photograph must be responsible to both. GARRY WINOGRAND, 1974

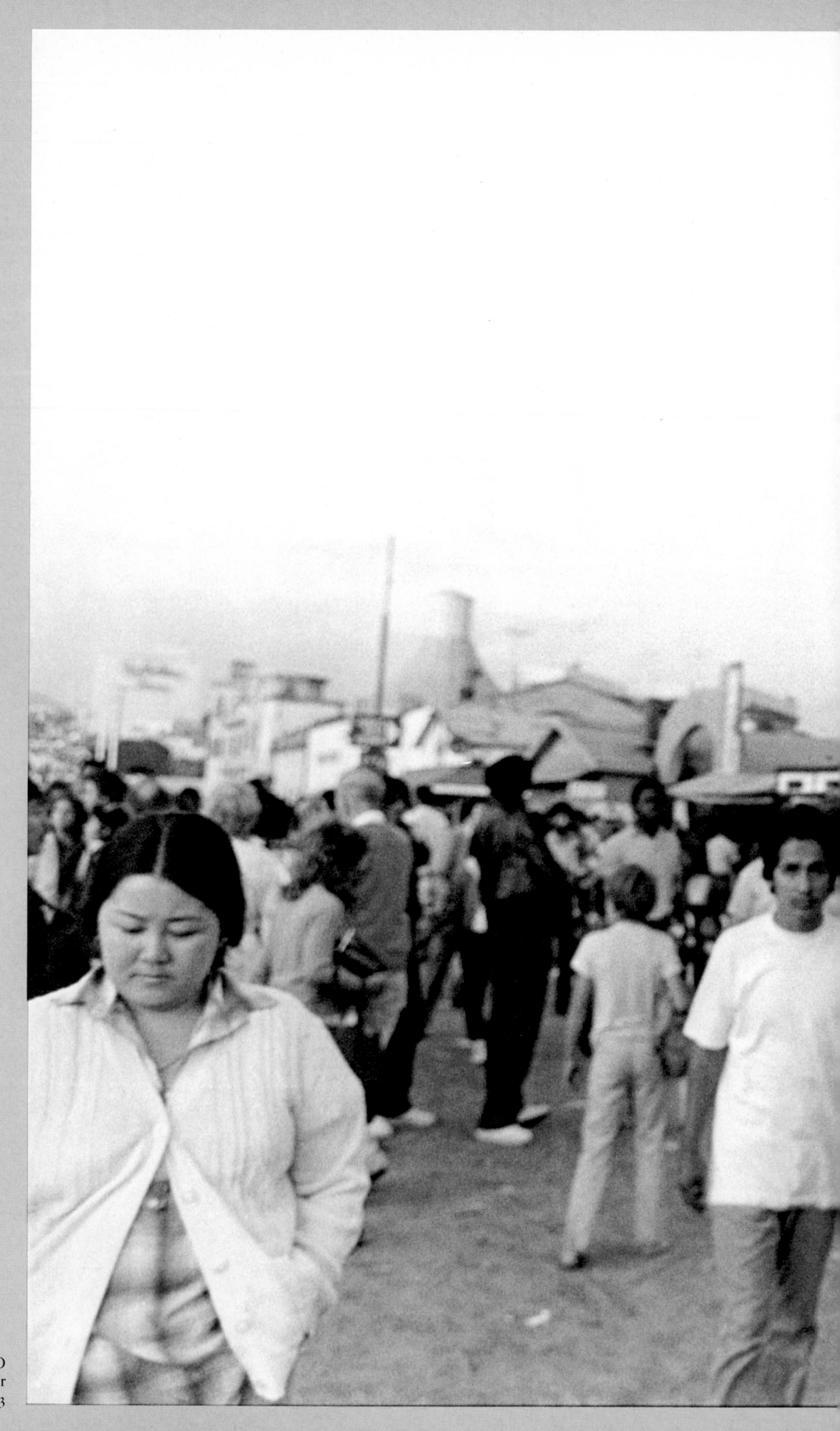

GARRY WINOGRAND
Santa Monica Pier
California, c. 1982–83

GARRY WINOGRAND
Santa Monica, California
c. 1982–83

GARRY WINOGRAND
Huntington Gardens
San Marino, California
c. 1982–83

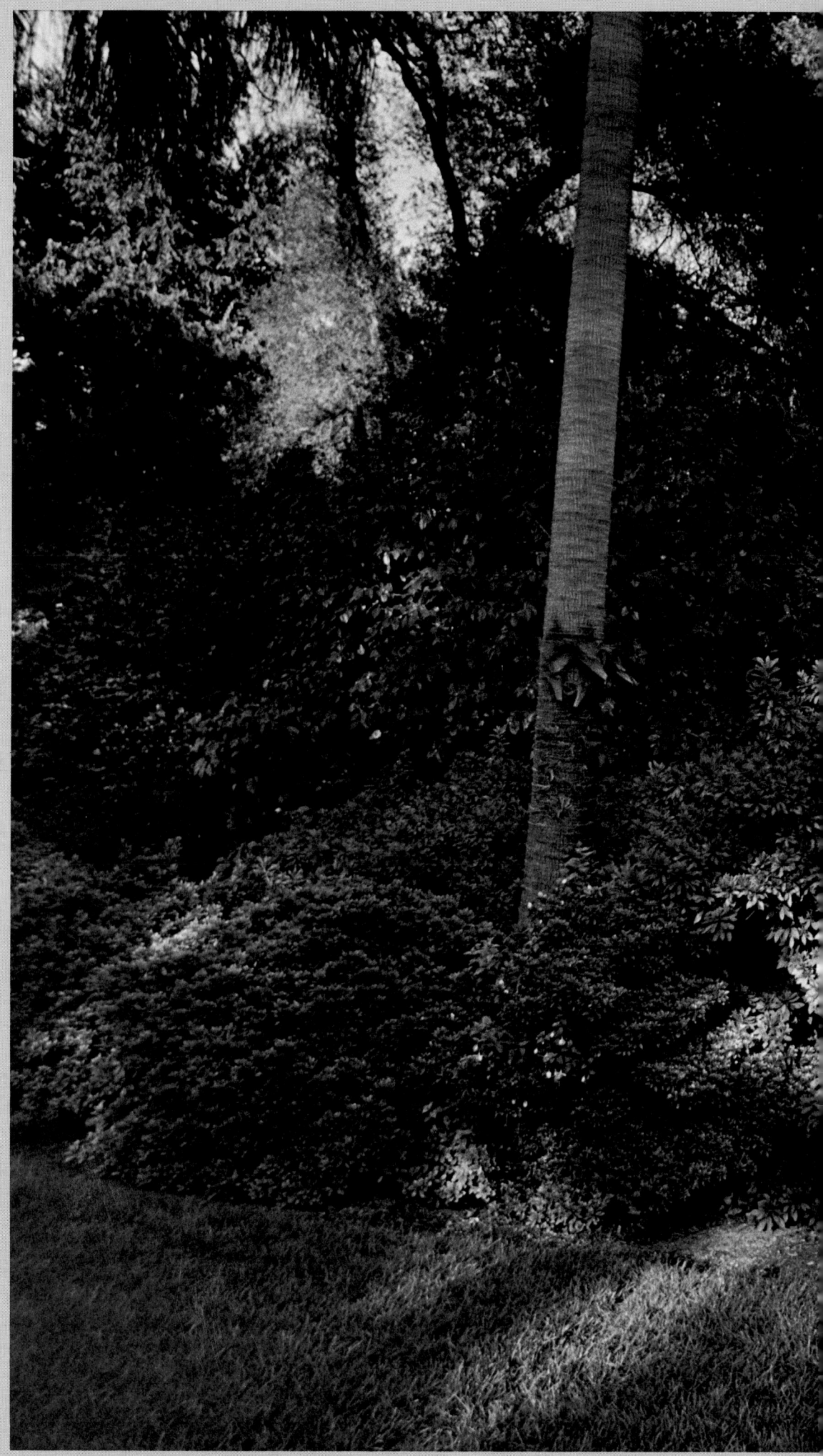

Garry Winogrand *and* Winogrand: Figments from the Real World *are part of the Springs Industries Series on Photography at The Museum of Modern Art and are generously supported by a grant from Springs Industries, Inc. Additional support for the exhibition has been provided by the NEA. Following its New York showing, the exhibition travels to the Art Institute of Chicago (Sept. 17–Nov. 13, 1988); the San Francisco Museum of Modern Art (Dec. 1988–Feb. 1989); the Carnegie Mellon University Art Gallery, Pittsburgh (Feb. 25–Apr. 16, 1989); the Museum of Contemporary Art, Los Angeles (June 13–Aug. 13, 1989); the Archer M. Huntington Art Gallery, University of Texas, Austin (Sept. 7–Oct. 22, 1989); and the Center for Creative Photography, University of Arizona, Tucson (Nov. 1989–Jan. 1990).*

Portrait, Berlin, 1923

Cellophane envelope which covered the portrait, Berlin, 1923

BARBARA BLOOM,
from the exhibition/installation,
"Found in Berlin", 1986

Apertif glasses, photo-engraved, 1986

When high-tech industries first came into the Philippines, my sister was ten years old. Too young to get a job. But I was older and had really good eyesight which is what you needed. So when I was 16 I went to work fitting tiny wires into microchip panels. Our family was closeknit, but the company made me move out and live in a dormitory. I started to wear makeup and dress American. By 19, my eyesight was very bad, because the hours we worked were so long and my eyes had been strained. I was fired. My father wouldn't let me live with the family because he didn't approve of the way I looked and dressed. I thought that I would be forced into prostitution. But I met an American man who helped me learn better English and sponsored me at word-processing school. A few years ago now, the Snap election was held. I was one of the word-processors who refused to falsify the election results, so that Marcos actually lost. But then I was in great physical danger, so an American journalist helped me to find a sponsor here, and I am working as word-processor today. Philippina woman in her 30's

JUDITH BARRY

(*above and opposite page*) First and Third, video beam projection
from The Whitney Biennial, 1987

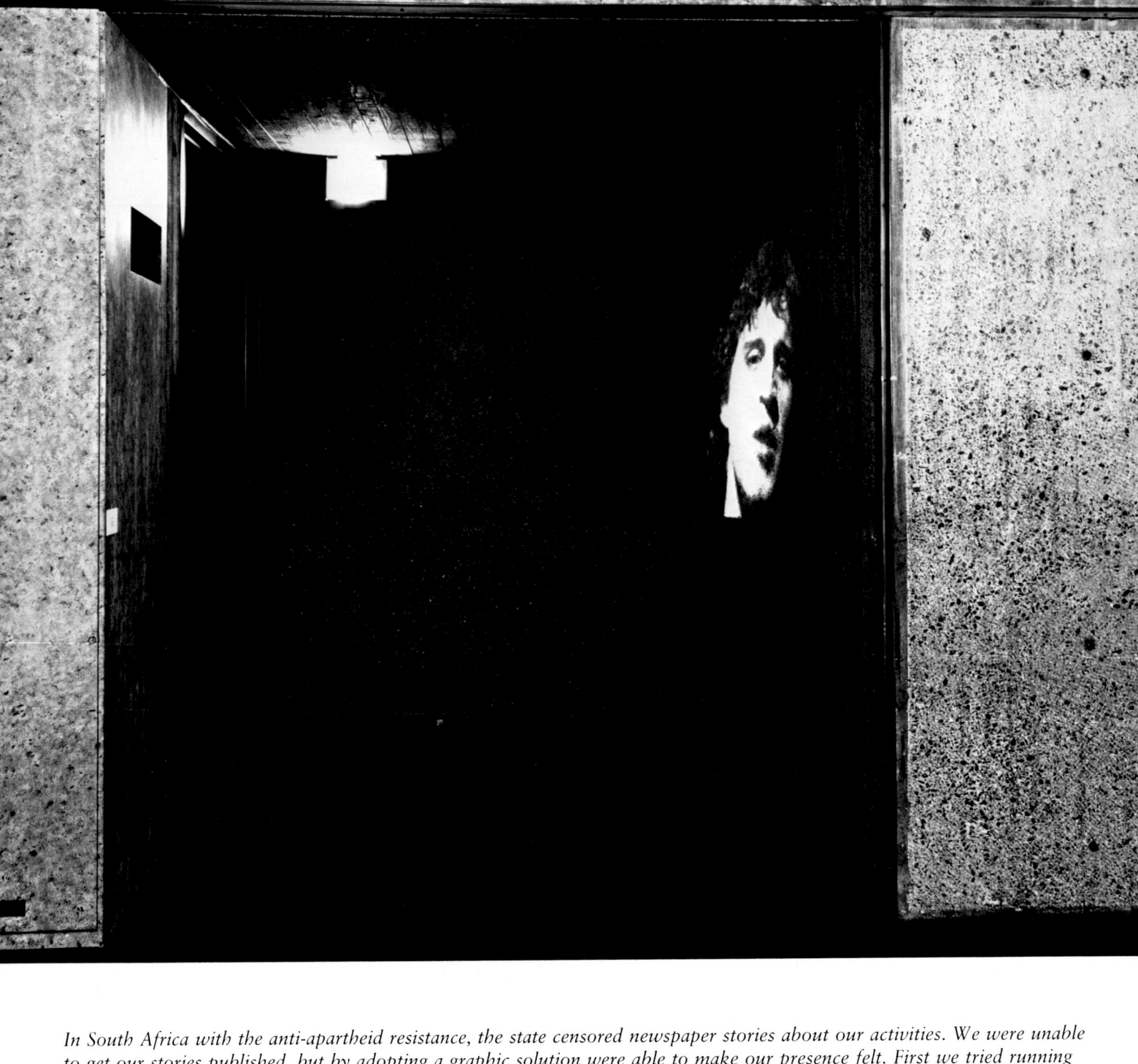

In South Africa with the anti-apartheid resistance, the state censored newspaper stories about our activities. We were unable to get our stories published, but by adopting a graphic solution were able to make our presence felt. First we tried running the stories as illegible scribbles with lines through them, since only the words themselves were illegal. But soon the state passed a law and that became illegal. Then we tried running the stories just as a series of lines—and that was censored. Finally we simply left blanks in the newspaper where the stories would have gone, so the paper became quite empty on the first few pages. I had to leave the country when this was declared illegal because another prison term might have meant execution. It seems that my journalist practice has continued in much the same way in the States. Since I have had almost nothing in the last few years, I have been unable to get a job. What is that slogan that you have, "publish or perish"?
South African journalist

People and Ideas

AFTER AGEE
by J. Ronald Green

Reviews of:

Rich and Poor *by Jim Goldberg, Random House, New York, 1985, $15.95 paperback.*

American Pictures: A Personal Journey through the American Underclass *by Jacob Holdt, American Pictures Foundation, New York, 1985. (Direct order from American Pictures, P.O. Box 2123, N.Y., N.Y. 10009, $18 hardcover, $15 paperback.)*

Below the Line: Living Poor in America *by Eugene Richards, Consumer Reports Books, New York, 1987, $32 hardcover, $20 paperback.*

Merci Gonaïves: A photographer's account of Haiti and the February Revolution *by Danny Lyon, Bleak Beauty, co-published with Filmhaus, 1988. (Direct order from Bleak Beauty Books, R.D.1, Box 150 Barclay Road, Clintondale, NY 12515, $17.95 plus $1.50 shipping, paperback.)*

Just as novelists after James Joyce have to wonder if there is anything more they can do with the novel form, social documentary photo-and-text bookmakers are confronted with the accomplishment of *Let Us Now Praise Famous Men*, by James Agee and Walker Evans. Its greatness marks what seems to be an expended impulse—to photograph and write about the poor. Actually, that impulse seems exhausted only from the point of view of patriarchy and privilege; Agee and Evans reached the heights from within a dominant sub-culture. Much of the glory of their accomplishments was in bringing cultural responsibility to consciousness in forms worthy of their subject. Part of their responsibility was existential—they were white, male, educated and empowered. The guilt in that responsibility, consciousness of which forms so much of the triumph of *Let Us Now Praise Famous Men*, might not be felt by a woman approaching the same subject. After Agee, social documentary might well be handed over to the disenfranchised—that is the logical consequence of Agee's work.

But we are a long way from doing that. All of the books reviewed here (as well as this review) are made by people like Agee and Evans. With only one partial exception they are all white, male, educated and empowered (the exception: Holdt is self-educated). Each in his own way has found strategies for continuing the Agee impulse.

Hollis Frampton once said that he would accept social documentary as an honorable activity only when artists could get in to photograph the private places (kitchens, bedrooms, and bathrooms) of the rich as often as they intruded on the poor (and he did not have Avedon and Lord Snowdon in mind). Jim Goldberg and Jacob Holdt both have done just that. Goldberg's *Rich and Poor* assumes that Americans' goal is to be rich, so he photographs that goal. But his book project did not recognize its own goal until mid-journey. It started out as a traditional social document of poor people living in a rotten hotel. Goldberg felt he could enter that world, take realistic photographs, then get the subjects to collaborate by writing messages on those photographs to the outside world. He wanted to show, in the Agee/Evans spirit, the nobility of people who struggle. What he discovered was despair ("I am *doomed* to be in this place, I have no future"); self-disdain ("The city has made me dislike myself now I get depressed easily, which makes me sleep alot and watch a lot of horror movies"); painful self-knowledge ("I am trying to be Something, Instead of that nothing I Look like. My Friend Jim the camerman came and Show me a mirror of my Self"); false hopes ("I am going to build an empire"); and anger ("This is my Fortress. I have power here. If I didn't have my kids; I would go get dynamite, and *Blow* this place Up!").

While reconsidering the import of his project, Goldberg decided to photograph the rich. This intuition recognizes Frampton's cogent assessment of social documentary and challenges the attitude toward social art of Les Krims's (great) satire, *Making Chicken Soup*. Goldberg's personal and social insight makes this book one of the best recent works of social art in the Agee tradition. What he intended to deliver to the outside world from the private spaces of the rich was a non-stereotyped humanity and individuality. What he found was selfishness ("I want to live my life without any obstacles, and become successful. Then I will be happy"); banality ("We are a contemporary family. We don't want to be part of the masses. We want to live with style!"); rationalization ("Poorer peoples' lives are less complicated. They do not have to worry about running such a big house, the boat needing constant repairs or the servants wearing spotless white uniforms"); reification ("I wish I could see *more* softness within myself—most of the time, as though in limbo, I feel caught between an iceberg and a desert"); inferiority ("I am not in awe of the art which surrounds me. I rearrange it every once in awhile. That satisfies me"); insensitivity ("My wife is acceptable. Our relationship is satisfactory"); fear ("I am

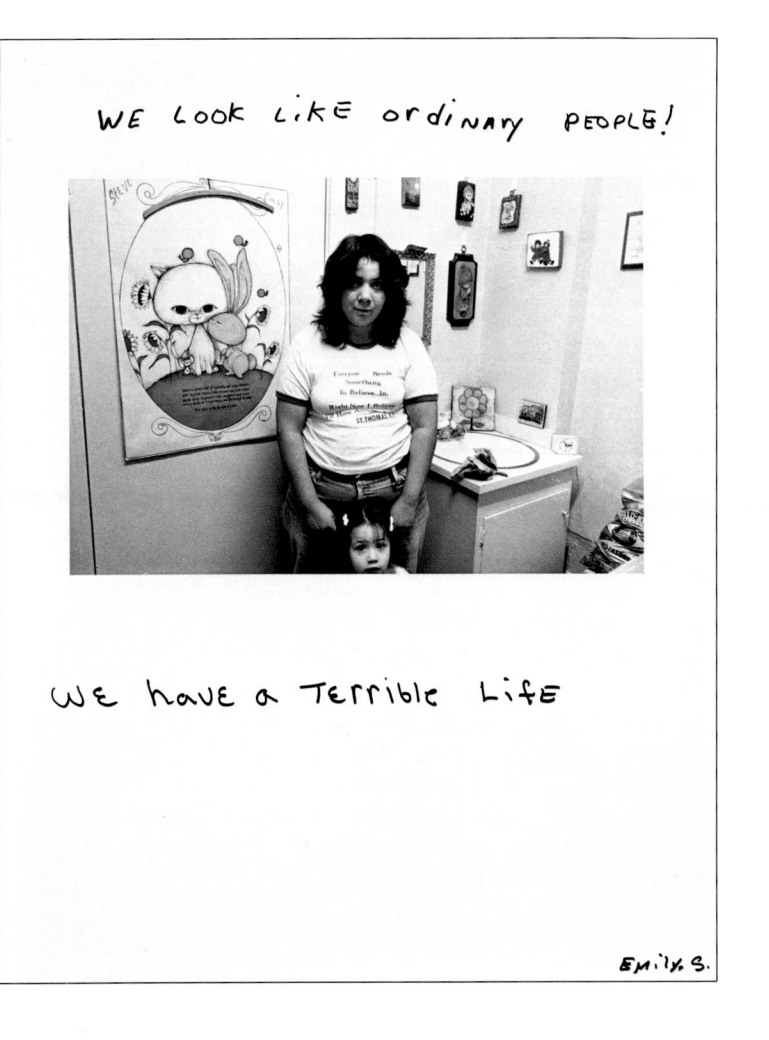

Jim Goldberg, from *Rich and Poor*, 1985

trapped . . . I have to have a super car, a super wife, a super house. I have at the bottom of everything a lack of self-confidence. I am afraid of being a loser"); self-disdain ("If you want to stunt your growth, be rich"); and despair ("For better or worse, my son will probably be very much the same"). The title *Rich and Poor* does not refer only to the dialectical array of subjects divided into class extremes; it also refers to the American Dream—the rich people of this book are rich *and* poor. It is saying to the woman on the cover (who writes "I STILL HAVE MY DREAMS. I would like an elegant home, a loving husband and the wealth I am used to") that her dreams are false. After reading this book, we would be justified in preferring Bill Owens's world to that of either class portrayed by Goldberg.

Goldberg's book is a sort of interim

assessment. He is reassessing a personal goal of art world success, represented by his rich subjects (selected from the board of directors of the art school he attended). In that sense he is like Agee. He is also exposing the rich for what they show themselves to be—soul-sick. Implicitly, this book calls for a different society which is not defined by the extremes of rich and poor ironically yearning for each other. It exposes the false desire that fuels our 200-year-old regime and keeps the rich and poor where they are, evidently contrary to their will or interests.

Jacob Holdt's *American Pictures* is a life's work manifested as a 35mm film, a five-hour slide-tape show, and a book (several editions, many languages). The film and slide-tape versions are overwhelming; the book does not wash over one in a single sitting, but it is powerful. Its 800 photographs and 100,000 words

span fifteen years of documentary vagabonding, independent social work, and guerilla philanthropy. Like *Let Us Now Praise Famous Men*, it immerses us in the lives of poor people. Holdt's story of racism and poverty is epic, Agee's is lyric. Since Holdt's is the journey of a European male through the New World, one is tempted to allude to Tocqueville, but Homer and Dante are more appropriate—Homer because of the epic timeframe of the journey, Dante because of the soul-stunning extremes of heaven and hell, and both Homer and Dante because of the brutality of description.

Holdt's writing, like Agee's, is self-conscious and confessional; his photographs, unlike Evans's, assume intimacy. Unlike Agee or Evans, Holdt's writing and photographic talents are merely adequate to his commitment, they never transcend it. However, his commitment

is virtually total, and that is what makes this a great work of social documentary and a contribution to the Agee impulse. Holdt spent ten years immersed in his subject, created an epic, and, deciding he had gotten it basically right, set about to devote his life to its findings. The book was a bestseller in Europe. He could have made a fortune on it, but instead he hired lawyers to break contracts and pull it out of circulation because of its success. He established a philanthropic foundation to publish and distribute it, using the profits for aid to Africa. There is no doubt it has sold hundreds of thousands fewer copies in the United States than it would have sold with a major publisher, but to Holdt it was more important that the production and distribution be managed by the underclass that the book was intended to help. He has made propagation a priority over propaganda. Holdt's answer to the moral contradiction, "poverty sells," is "then let the poor sell it, at least."

Amateurs have control of the whole American Pictures project, beginning with Holdt himself. That amateurism is a great strength. One of the strains of the Agee impulse that offers some promise for social documentary is artistic enfranchisement. Every project that succeeds outside the current system of gatekeeping offers the possibility of mutation, since an uncontrolled voice will be heard by an uncontrolled audience. Holdt says "I have now made so many safe-guards around this book to avoid exploitation, that I have finally come to believe in it as a meaningful tool for change." Agee had little expectation that his book would effect social change, and he thought it ought to be released on newsprint so it would disintegrate. Compared to Agee Holdt is naive, but less cynical.

Holdt's work is deeply and permanently affecting. He has been invited to return repeatedly to American colleges, especially in the Ivy League, apparently reaching successful liberals as social documentary has rarely done. I hope Holdt's project succeeds because there is so much suppressed American reality in it. But it also has its problems. The vagabonding and "yes" philosophy (Holdt made it a policy to say "yes" to whomever he was with—sex partners, criminals, the Indians

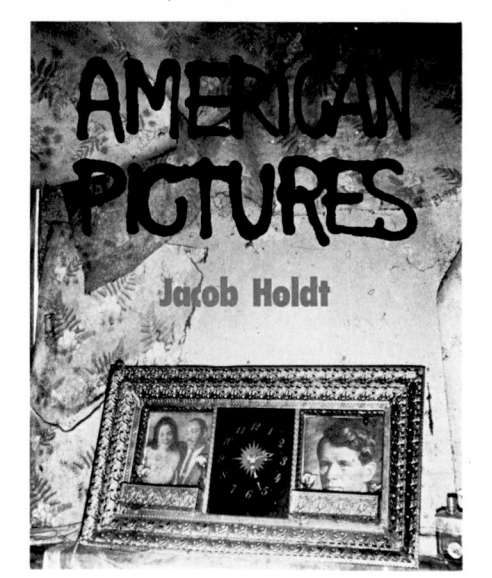

Jacob Holtd, *American Pictures*, (cover), 1985

at Wounded Knee, white supremacists— in order to "understand their points of view") that are at the center of his social documentary method cannot be replicated by non-white, non-males. A woman or a man of color could not do what Holdt did without turning into a victim. For Holdt vagabonding was risky, for a woman or a black man it could be suicide. Its well-intentioned method would seem to be—when applied in America— structurally paternalistic; for social documentary, that is certainly a limitation. Holdt's project would not be ill served by a sense of irony; some of his current detractors might become allies. (Barbara Kruger's review in the November 1984 issue of *Artforum* criticizes Holdt's "sloppy sexism" and messianism.)

Social documentary artists sometimes try to counter the effects of objectification of human subjects by adopting strategies of identifying with them, thereby more directly experiencing their subjects' lives. It is a way of attaining (or pretending to) the knowledge of another. Both Goldberg and Holdt adapt to their subjects' environments. Goldberg includes two pictures of himself, one, where he looks poor, to introduce the poor-people's section; and the other, where he looks rich, to introduce the rich (he explains this in his closing essay). Holdt lends his consciousness almost entirely to whomever he is with, in order to gain access to her/

his self-knowledge. By these strategies they both give their readers a way to know their subjects (I am not going to discuss the ethics of these methods, which are baroque).

Eugene Richards, in *Below the Line*, adopts two major strategies to recruit the reader's investment in his subjects: he includes the average American among his poor; and he lets his subjects speak for themselves (what William Stott, in *Documentary Expression and Thirties' America*, calls "informant narrative"). Richards's book is a collection of small portfolios about individuals and families facing poverty; each person is named (some names are changed) and located geographically. Richards recognizes that when middle-Americans look at pictures of the poor, they rarely see themselves. By beginning his series of portraits in the heartland—Gann Valley, South Dakota—with an all-American farm family, Richards is inviting the average American to identify with the people in this book. The text emphasizes work—one underclass couple who looks devastated in the photographs has never stopped working: "I working many different jobs. I work at the coat factory on Second Street— jackets, everything for the ladies. I work there eight years."

The middle-Americans who saw themselves in the farmers' struggle can also identify with the slum dwellers' values. These poor are not white trash who "don't deserve to succeed"— they are people, as in the farmers' story, who have worked all their lives but are not making it.

These are important strategies—to guide (like Virgil) the middle class (like Dante) gradually into the underclass, and to give the subjects the space to tell their own stories. As Stott shows, publishing disenfranchised voices is not a new documentary strategy. After critics complained when Taylor Caldwell and Margaret Bourke-White did not allow their subjects their own words in *You Have Seen Their Faces*, many bookmakers began including their subjects' words (recently, Bill Owens, Danny Lyon, Jim Goldberg). Guides to the underclass are commonplace in liberal cinema, as in *Cry Freedom*, which provided a white hero for white audiences, thereby deflecting

on how to guide creative children. His work is in the collection of the Museum of Modern Art, New York and the Library of Congress. He died in 1981.

CHARLES ROTKIN was an aerial photographer for Standard Oil and the last major photographer hired by Stryker. He has published *Europe: An Aerial Close-up* (1962) and *The USA: An Aerial Close-up* (1968) and operates his own small mid-Manhattan firm, Photography for Industry.

WALTER ROSENBLUM was born on the Lower East Side of New York in 1919. He was the most decorated photographer in the Armed Services, awarded the Silver Star, Bronze Star and Purple Heart. Member (and former president) of the Photo League from 1937 to 1952, he received fellowships from the NEA and the Guggenheim (1978). In 1947, he became a professor of art at Brooklyn College and retired in 1987.

HAROLD ROTH started photographing when he was sixteen and has continued for the past fifty-three years. Photography is an avocation for Roth, whose long time work has been as a model-maker in a machine shop. Influenced by Berenice Abbott, Ansel Adams, Edward Weston, Henri Cartier-Bresson and the Photo League, Roth's work has received many awards and is available through the Witkin Gallery and Photofind Gallery in New York.

LORNA SIMPSON is an independent photographer living in New York City. She has received an NEA Fellowship (1985) and has exhibited at various galleries and museums in the U.S.

AARON SISKIND's work is in most U.S. collections, including the Museum of Modern Art, New York, the Art Institute of Chicago, and the Museum of Fine Art, Houston. He is a recipient of the Guggenheim Fellowship (1966) and the Distinguished Career in Photography Award, Friends of Photography (1981). He has been a subject and author of many books, notably, *Aaron Siskind: Pleasures and Terrors*, by Carl Chiarenza (Little Brown, 1982). Siskind joined the Photo League in 1932.

LOUIS STETTNER, a writer and teacher as well as a photographer, has always championed humanism as photography's most important goal. A freelance photographer living in New York since 1949, he is a recipient of the NEA fellowship (1974) and his work is included in the collections of the George Eastman House and the Museum of Modern Art, New York. He is the author of *Early Joys* (Light Impressions, 1987).

MAREN STANGE is assistant professor of communications and American studies at Clark University in Worcester, Massachusetts. Her book, *Symbols of Ideal Life: Social Documentary Photography in America, 1890–1950*, will be published this fall by Cambridge University Press. Winner of a Logan Award for New Writing on Photography and a contributor to *Prospects, Afterimage, Views*, and the *Boston Review*, she has held fellowships from the Center for Advanced Study in the Visual Arts, the American Council of Learned Societies, and the Smithsonian Institution.

JOSEPH SCHWARTZ was born in Brooklyn, and at an early age began photographing on the streets of New York. He was a combat photographer during World War II, and joined the Photo League at the suggestion of photographer David Robbins. Living in Los Angeles, he is currently working on a book project, *Folk Photography*.

JOHN VACHON was a photographer for the FSA and SONJ under Roy Stryker. Staff photographer for both *Life* and *Look* magazines, Vachon received a Guggenheim Fellowship in 1973. His work is included in the collections of the Art Institute of Chicago and the Museum of Modern Art, New York. Vachon died in New York in 1975.

DAN WEINER was born in 1919 in New York. Weiner was a freelance photographer working for *Collier's, Fortune*, and *Harper's Bazaar* during the 1950s, and a member of the Photo League from 1940 to 51. In 1956 he published *South Africa in Transition*, a collaboration with writer Alan Paton. His work appeared in the "Concerned Photographer" exhibition in 1967 and is in the collections of

the ICP, the Museum of Modern Art, New York and the George Eastman House. Weiner died on assignment in a plane crash in 1959.

SANDRA WEINER began photography in 1942 as a student of Paul Strand at the Photo League. She worked from 1950 to 1959 as a photojournalist with her husband, Dan Weiner. After his death, she began writing and photographing books for children, including *Small Hands, Big Hands* (Pantheon), *It's Wings that Make Birds Fly* (Pantheon), and several others. She taught photography at City College, New York and is presently organizing an exhibition and book of Dan Weiner's work at the Museum of Modern Art, New York.

GARRY WINOGRAND was born in 1928 in the Bronx and began to photograph in 1948, working as a photojournalist and advertising photographer. His exhibitions at the Museum of Modern Art, New York included, "The Animals" (1969), "Public Relations" (1976) and the group exhibitions "Five Unrelated Photographers" (1963) and "New Documents" (1967). He taught at Chicago's Institute of Design and at the University of Texas in Austin, and received three Guggenheim Fellowships and an NEA. He died in New York in 1984.

BRIAN WALLIS is a writer and editor living in New York. Currently an editor at *Art in America*, Wallis was co-founder of *Wedge* magazine. His recent publications include *Art After Modernism* (MIT, 1986) and *Blasted Allegories* (MIT, 1987). He was also curator of "This is Tomorrow, Today," an exhibition at P.S.1, New York, in 1987.

CARRIE MAE WEEMS is completing her masters program on Afro-American Folklore and American Feminist Literature at the University of California, Berkeley. She is currently a visiting professor of photography at Hampshire College in Amherst, Mass.

NOTES

"A Good Honest Photograph": Steichen, Stryker and the Standard Oil of New Jersey Project

[1]See my " 'The Record Itself': Farm Security Administration Photography and the Transformation of Rural Life," Pete Daniel, Merry A. Foresta, Maren Strange, and Sally Stein, Official Images: New Deal Photography (Washington D.C.: Smithsonian Institution Press, 1987), p. 4. Christopher Phillips's "Steichen's Road to Victory," Exposure 18:2 (1981) p. 41, notes that "the huge photomurals which were constructed from enlarged FSA photographs and raised in Grand Central Station in December, 1941" probably mark "the first instance after Pearl Harbor in which documentary photographs were adapted to purposes of propaganda." [2]Stange, "The Record Itself," p. 4. [3]Edward Steichen, ed. The Bitter Years, 1935–1941: Rural America as seen by the photographers of the Farm Security Administration (New York: The Museum of Modern Art, 1962), p. iii. [4]David Hunter McAlpin to Roy E. Stryker, May 22, 1942, "Road to Victory" file, Department of Photography, Museum of Modern Art, New York (hereafter cites as MOMA). [5]Eva Cockcroft, "Abstract Expressionism, Weapon of the Cold War," Artforum, vol. 12, no. 10 (June, 1974), pp. 39, 40; see Christopher Lasch, The Agony of the American Left (New York: Vintage Books, 1969), ch. 3. [6]Monroe Wheeler, "A Note on the Exhibition," Bulletin of the Museum of Modern Art, IX, no. 5–6 (June, 1942), p. 19; Christopher Phillips, "The Judgment Seat of Photography," October, 22 (Fall, 1982), p. 46. Though The Family of Man will not be discussed specifically here, my understanding of Steichen's post-war work has greatly benefited from recent criticism of Family including Roland Barthes, "The Great Family of Man," in his Mythologies, trans. Annette Lavers (New York: Hill and Wang, 1970), pp. 100–102; Jonathan Green, American Photography: A Critical History 1945 to the Present (New York: Harry N. Abrams, Inc., 1984); ch. 2, Eric J. Sandeen, "The Family of Man at the Museum of Modern Art: The Power of the Image in 1950s America," Prospects, 11 (New York: Cambridge University Press, 1987), pp. 367–391; Allan Sekula, "The Traffic in Photographs," in his Photography Against the Grain: Essays and Photo Works 1973–1983 (Halifax: The Press of the Nova Scotia College of Art and Design, 1984), pp. 76–101. [7]Phillips, "Judgment Seat," pp. 39–40; p. 41, n. 35; p. 45, n. 43; p. 48 [8]Unidentified quotation, Bulletin of MOMA, p. 21. [9]Bulletin of MOMA, p. 19, p. 20; H. M. Carleton to Editor, New York Herald Tribune, May 25, 1942, MOMA. [10]Phillips, "Steichen's Road," p. 42; Bulletin of MOMA, p. 20. See Phillips, "Judgment Seat," p. 46, n. 46. [11]Phillips, "Judgment Seat," pp. 43, 46. [12]Phillips, "Steichen's Road," p. 38; Bulletin of MOMA, p. 21; Phillips, "Judgment Seat," p. 43. On The Family of Man, see Green, American Photographs, pp. 47–51. Roland Marchand, Advertising the American Dream: Making Way for Modernity 1920–1940 (Berkeley: University of California Press, 1985), ch. 5 discusses the ways that advertising used "modern art forms" to associate products with the " 'smartness' of novelty, fashion, and the latest mode" (p. 142). [13]Cockcroft, "Abstract Expressionism," pp. 39–40. [14]Cockcroft, "Abstract Expressionism," p. 41; Gary O. Larson, The Reluctant Patron: The United States Government and the Arts, 1943–1965 (Philadelphia: University of Pennsylvania Press, 1983), p. 57; Cockcroft, "Abstract Expressionism," p. 40; Russell Lynes quoted in Cockcroft, "Abstract Expressionism," p. 40. On the topic of U.S. government promotion of abstract expressionism, see also Max Kozloff, "American Painting during the Cold War," Artforum, 11 (May, 1973), pp. 43–54, and Serge Guilbaut, How New York Stole the Idea of Modern Art, trans. Arthur Goldhammer (Chicago: The Univeristy of Chicago Press, 1983). [15]Larson, Reluctant Patron, p. 58. [16]Guilbaut, How New York, pp. 55–56, 91–92, 86–87. [17]John Morton Blum, quoted in Steven W. Plattner, "How the Other Half Lived: The Standard Oil Company (New Jersey) Photographic Project, 1943–1950," M.A. Thesis, George Washington University, 1981, p. 7. [18]Plattner, "How the Other Half," pp. 7, 13–14, 15–16, 42, 254. [19]The Rosskams are quoted in Plattner, "How the Other Half," p. 108; George Freyermuth, head of SONJ's public relations department, is quoted in Plattner, "How the Other Half," p. 19. On the philosophy of New Deal arts projects, see Karal Ann Marling, Wall-to-Wall America (Minneapolis: University of Minnesota Press, 1982). On CIA cultural activities, see Lasch, Agony, ch. 3 and see Frances K. Pohl, "An American in Venice: Ben Shahn and United States Foreign Policy at the 1954 Venice Biennale or Portrait of the Artist as an American Liberal," Art History, vol. 4, no. 1 (March, 1981) pp. 80–108. [20]The phrase is used by Terence Edwin Smith, "Making the Modern: The Visual Imagery of Modernity, U.S.A., 1908–1939" (Ph.D. diss., University of Sydney, Australia, 1985), p. 357. David E. Nye, Image Worlds: Corporate Identities at General Electric (Cambridge: The MIT Press, 1985) discusses the uses that the General Electric corporation made of its commercially produced photographic archives from 1890 to 1930, and touches on corporate use of other forms of art. [21]Plattner, "How the Other Half," pp. 17, 27, 28. "By the mid- to late-1940s, abstract expressionists were lauded not only in Partisan Review, The Nation, Magazine of Art and Art News, but also in popular magazines such as Life," writes historian Jane deHart Mathews, "Art and Politics in Cold War America," American Historical Review, 81 (October, 1976), p. 783. William Stott, Documentary Expression and Thirties America (New York: Oxford University Press, 1973) surveys literature, theater, and the media during the 1930s and early 1940s in terms of a "documentary movement" characteristic of the time. [22]"A Portrait of Oil—Unretouched," Fortune (September, 1948), pp. 102, 104; Edwin Rosskam quoted in Plattner, "How the Other Half," p. 3. See also Stuart Ewen, Captains of Consciousness: Advertising and the Social Roots of the Consumer Culture (New York: McGraw-Hill Book Company, 1976); See also Richard Wightman Fox and T. J. Jackson Lears, eds., The Culture of Consumption: Critical Essays in American History, 1880–1980 (New York: Pantheon Books, 1983). [23]Plattner, "How the Other Half," pp. 51, 52; Barthes, Mythologies, p. 101. [24]Plattner, "How the Other Half," pp. 62, 96, 119–127. [25]Arthur Calder-Marshall, The Innocent Eye: The Life of Robert J. Flaherty (New York: Harcourt, Brace & World, Inc., 1963), pp. 211, 238, 223; Plattner, "How the Other Half," p. 96; According to SONJ project librarian Sally Forbes, "the company's interest began to turn toward television" after the success of Louisiana Story. She is quoted in Plattner, "How the Other Half," p. 124. [26]Roy E. Stryker, "Documentary Photography," The Complete Photographer, Willard D. Morgan, gen. ed. (New York: National Educational Alliance, Inc., 1942), p. 1368, 1369. [27]Michael Schudson, Discovering the News: A Social History of American Newspapers (New York: Basic Books, Inc., 1978), pp. 157, 156. [28]Alfred H. Barr, "Is Modern Art Communistic?" The New York Times Magazine (December 14, 1952), pp. 22–23. An interesting gloss on the issue is Walker Evans's 1971 remark: "The word 'documentary' is a little misleading. Literally, documentary is a police photograph of an automobile accident which says nothing and is not supposed to say anything. What we conscious photographers now think of as documentary has a personal style to it, in this guise of objectivity which some of us fell in line with." In Still/3 (Rochester, N.Y.: dist. Light Impressions, 1973), p. 2; see also Leslie Katz, "Interview with Walker Evans," Art in America, 59 (March, 1971), p. 87. [29]On the Photo League, see Ann Tucker, "Photographic Crossroads: The Photo League," A Special Supplement to Afterimage, No. 25, April 6, 1978; see Photonotes (Rochester, N.Y.: A Visual Studies Reprint Book, 1977. Serge Guilbaut, "The New Adventures of the Avant-Garde in America: Greenberg, Pollock, or from Trotskyism to the New Liberalism of the 'Vital Center,' " October, 15 (1980) pp. 61–78; Cockcroft, "Abstract Expressionism," p. 41. [30]Jack Kerouac, "Introduction" to Robert Frank, The Americans (New York: Grove Press, 1959, reprinted Millerton, N.Y.: Aperture, Inc., 1969, 1978), p. 5. [31]Green, American Photography, p. 85.